LANCASHIRE
IN PHOTOGRAPHS

JON SPARKS

AMBERLEY

First published 2017

Amberley Publishing
The Hill, Stroud
Gloucestershire, GL5 4EP

www.amberley-books.com

Copyright © Jon Sparks, 2017

The right of Jon Sparks to be identified as the Author of this work has been
asserted in accordance with the Copyrights, Designs and Patents Act 1988.

ISBN 978 1 4456 6730 0 (print)
ISBN 978 1 4456 6731 7 (ebook)

British Library Cataloguing in Publication Data.
A catalogue record for this book is available from the British Library.

Origination by Amberley Publishing.
Printed in the UK.

ABOUT THE PHOTOGRAPHER

Jon Sparks is a freelance photographer and writer specialising in the outdoors. He's been based in Lancashire all his working life, and founded his professional career on images of the county and adjoining areas. While he's had fantastic experiences in New Zealand, Pakistan, Jordan and other far-flung spots, many of his favourite places are much closer to home. Jon now lives in Garstang and counts himself lucky to have the Forest of Bowland on his doorstep.

Alongside pure landscape photography, he's worked extensively on outdoor pursuits; in fact he'd argue that there's no hard boundary between the two. He's tried most activities but has a special love of all things bike-related, whether skinny-tyred road bikes or mountain bikes. He's also a lifelong hill walker, scrambler and 'resting' rock climber. He's picked up awards for both writing and photography, and indeed has written extensively about photography.

INTRODUCTION

Photographing Lancashire has been an important part of my professional life for over twenty-five years, and I was doing it as an amateur long before that – there must be something about the place that keeps me going.

There's plenty of landscape quality, for a start. Lancashire has a half-share in one Area of Outstanding Natural Beauty (AONB) – Arnside-Silverdale – and the lion's share of another, the Forest of Bowland. Since the extension of National Park boundaries in 2016, it also has a toehold in the Yorkshire Dales National Park. There are many other cherished areas too; for example, a large swathe of the West Pennine Moors recently became the largest new Site of Special Scientific Interest created since 2004. Inevitably, the selection of photos leans heavily on these noted areas, but there's plenty more to enjoy.

Another factor that helps keep me fresh is exploring Lancashire in a range of different ways. Walking is always a natural complement to landscape photography, of course, but I've gained different and equally valuable perspectives from both road and mountain bikes. As Ernest Hemingway said, 'It is by riding a bicycle that you learn the contours of a country best, since you have to sweat up the hills and coast down them.' Rock climbing and the odd bit of ghyll-scrambling have brought me up close and personal with yet more corners of the county.

I said I've been photographing Lancashire for a long time. I should have added that I'm not tired of it yet. It may not have made me rich, but it's made my life richer.

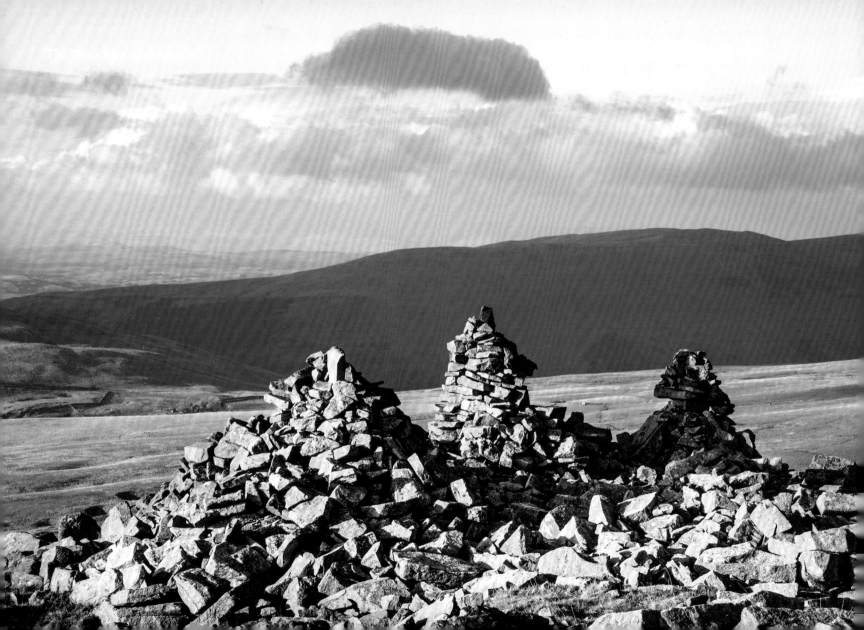

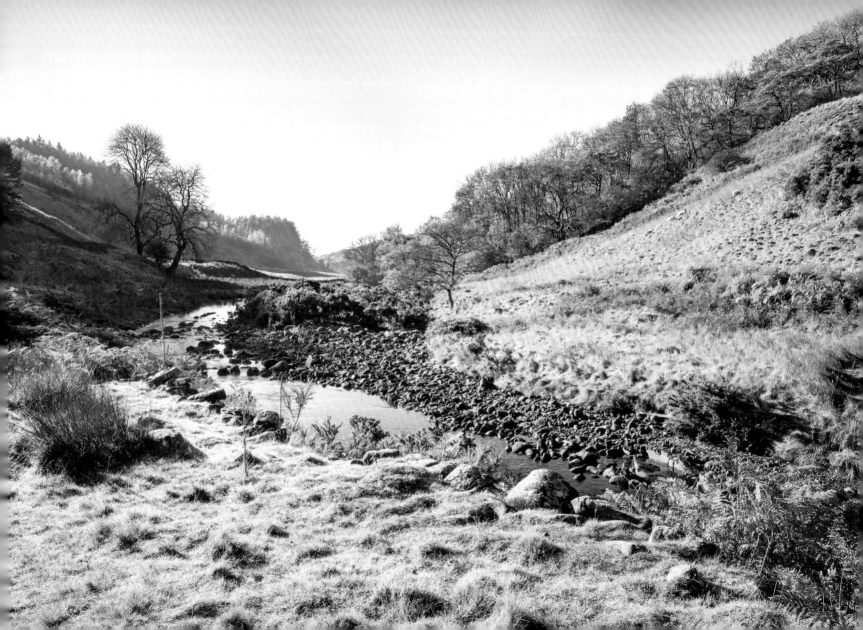

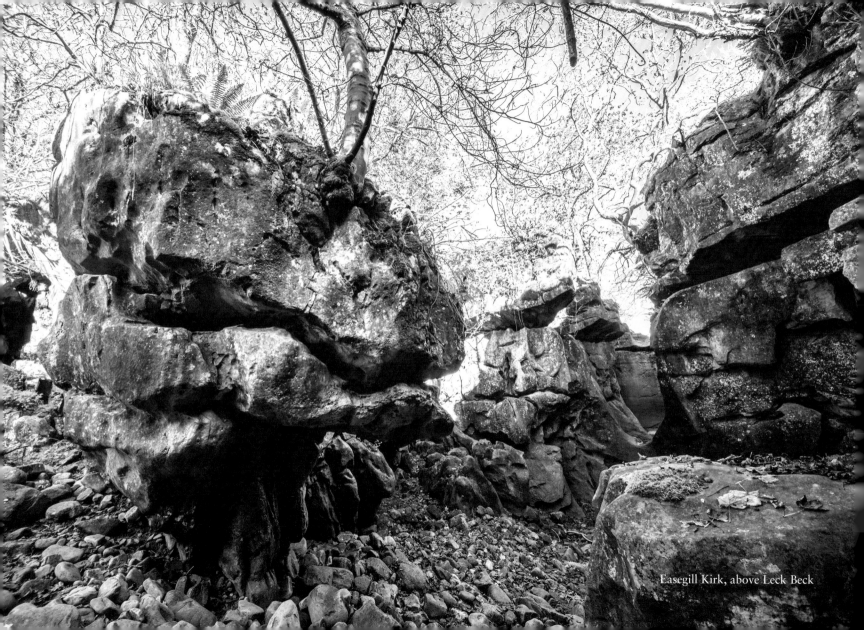

Easegill Kirk, above Leck Beck

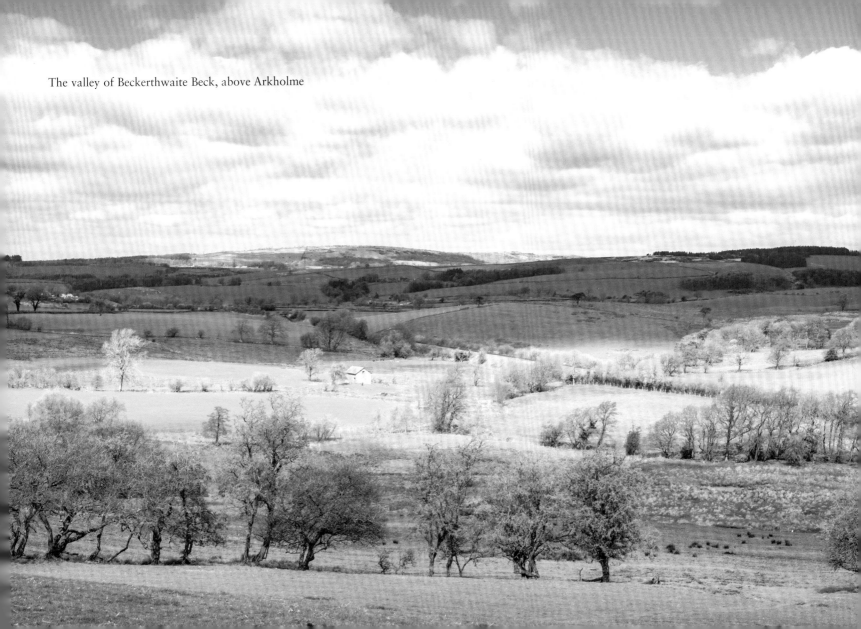

The valley of Beckerthwaite Beck, above Arkholme

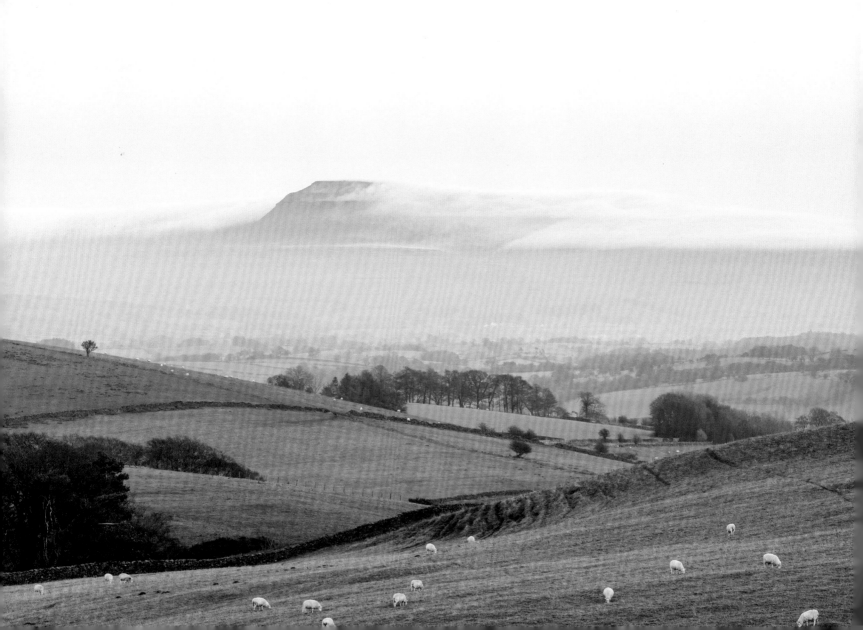

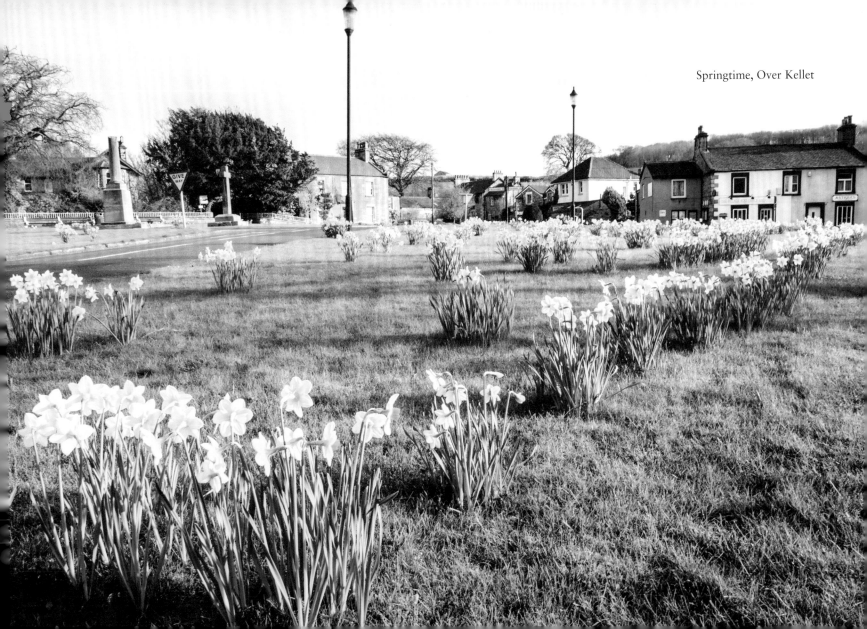

Springtime, Over Kellet

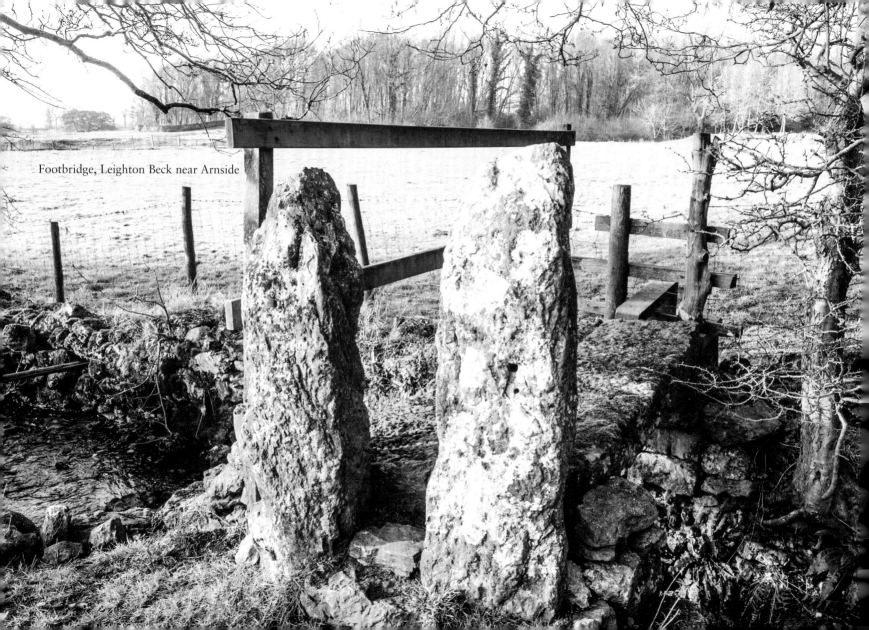

Footbridge, Leighton Beck near Arnside

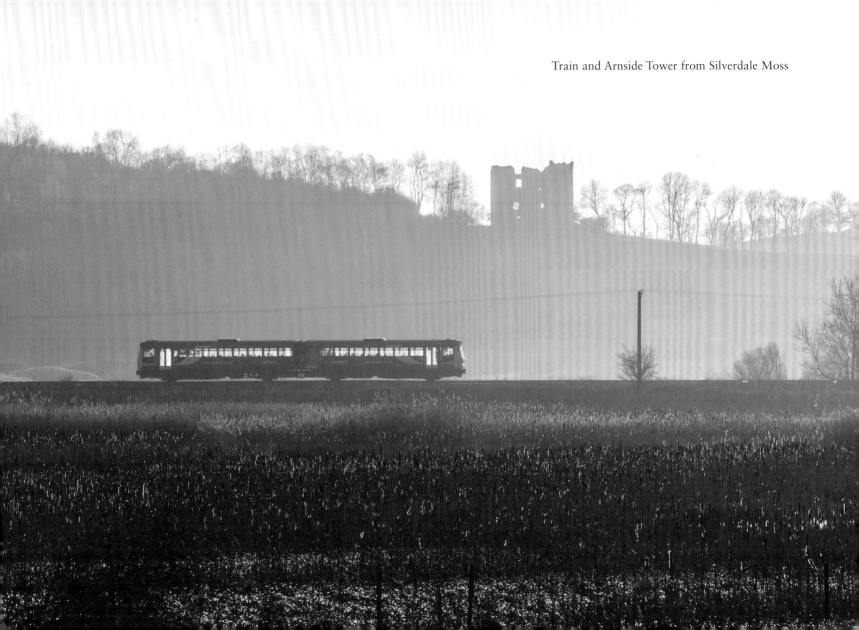

Train and Arnside Tower from Silverdale Moss

Moss on wall, Silverdale Moss

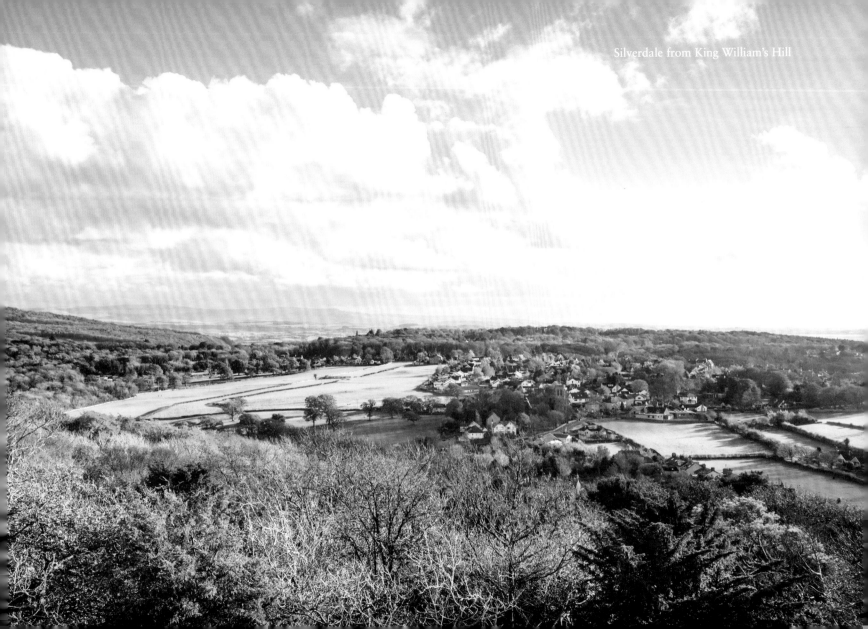
Silverdale from King William's Hill

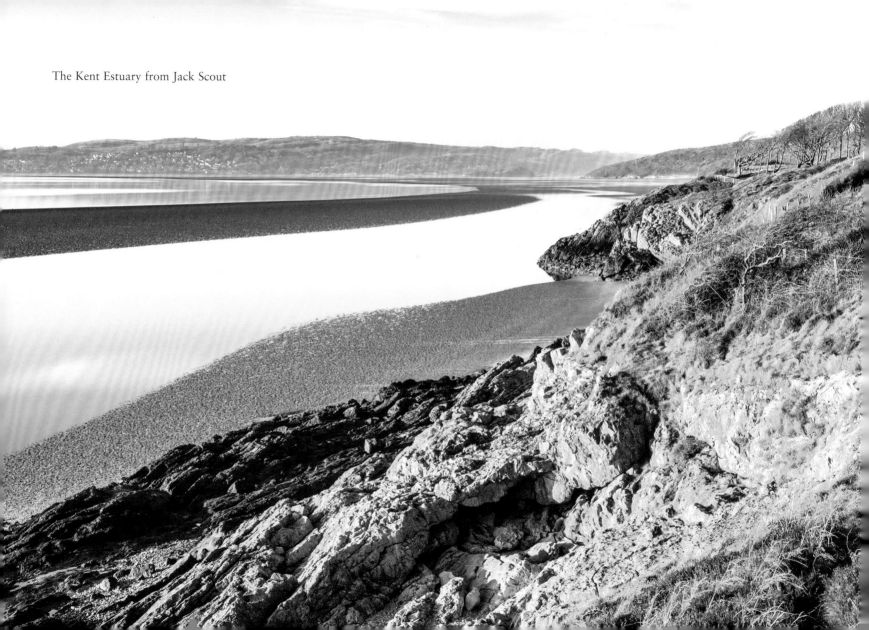

The Kent Estuary from Jack Scout

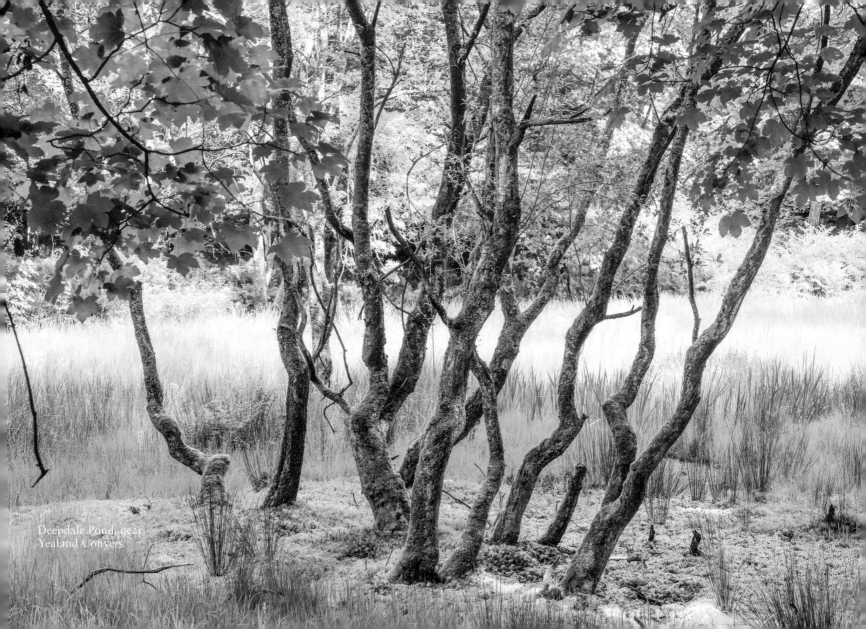

Deepdale Pond, near
Yealand Conyers

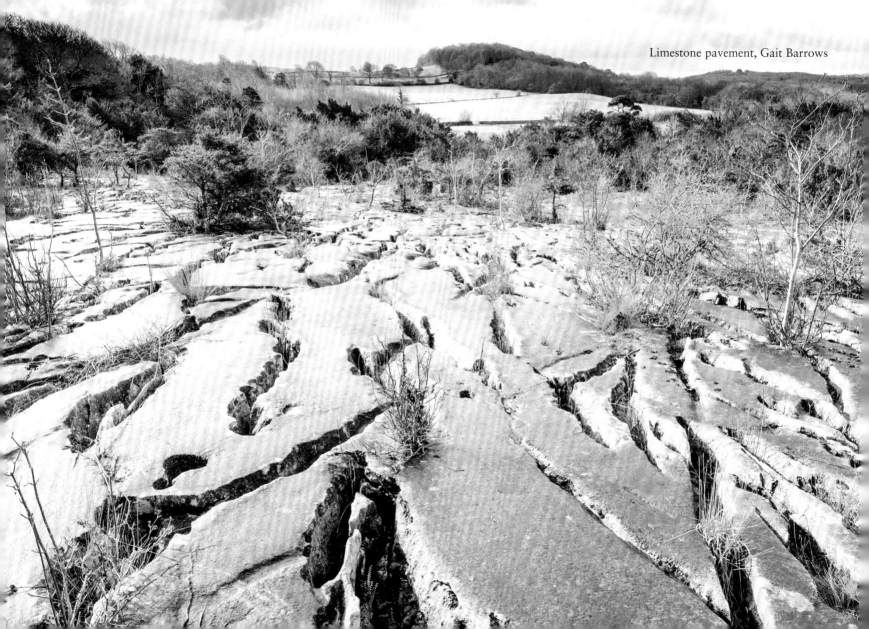
Limestone pavement, Gait Barrows

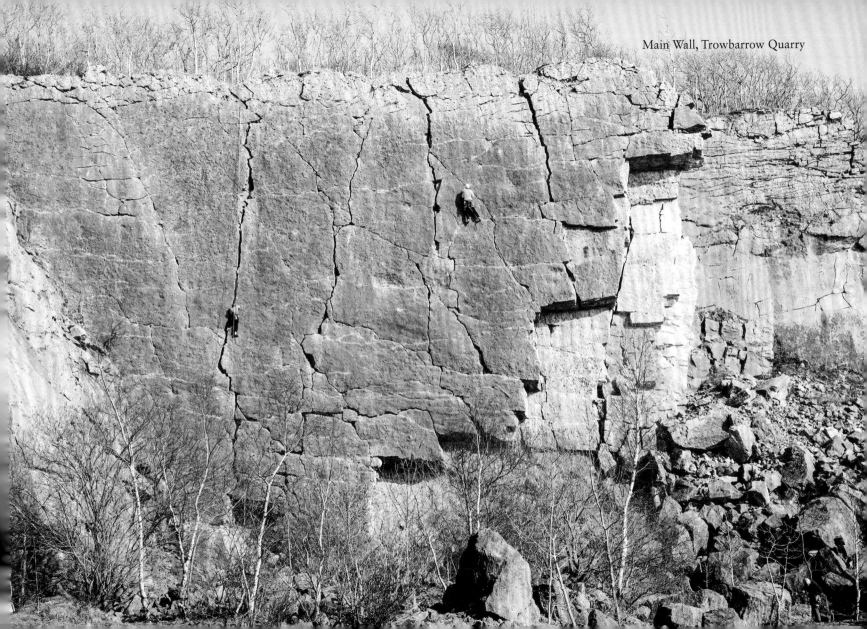

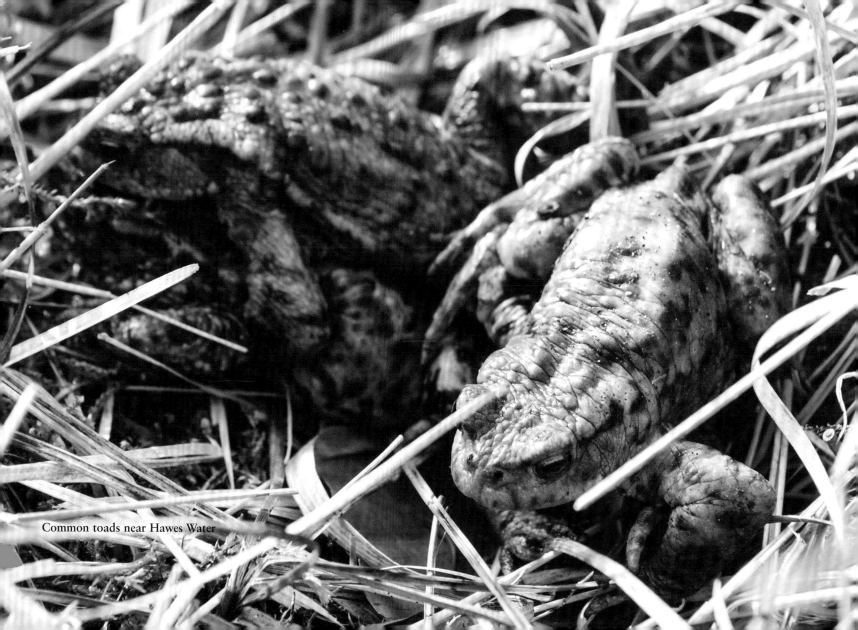

Common toads near Hawes Water

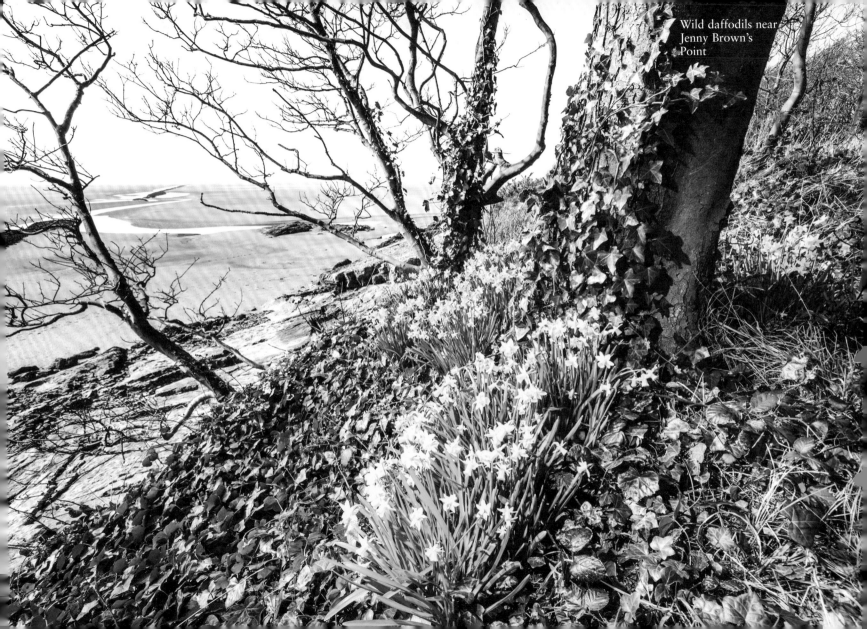

Wild daffodils near
Jenny Brown's
Point

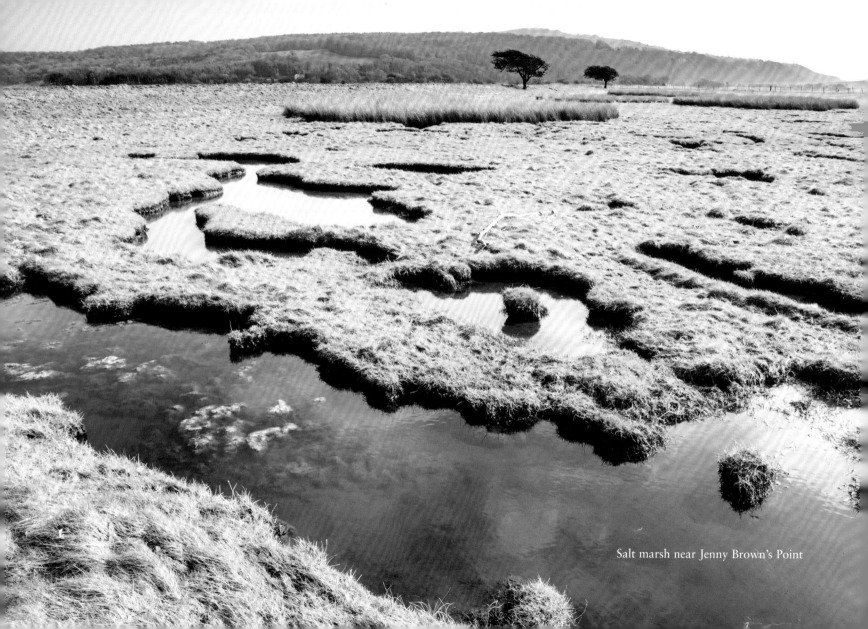

Salt marsh near Jenny Brown's Point

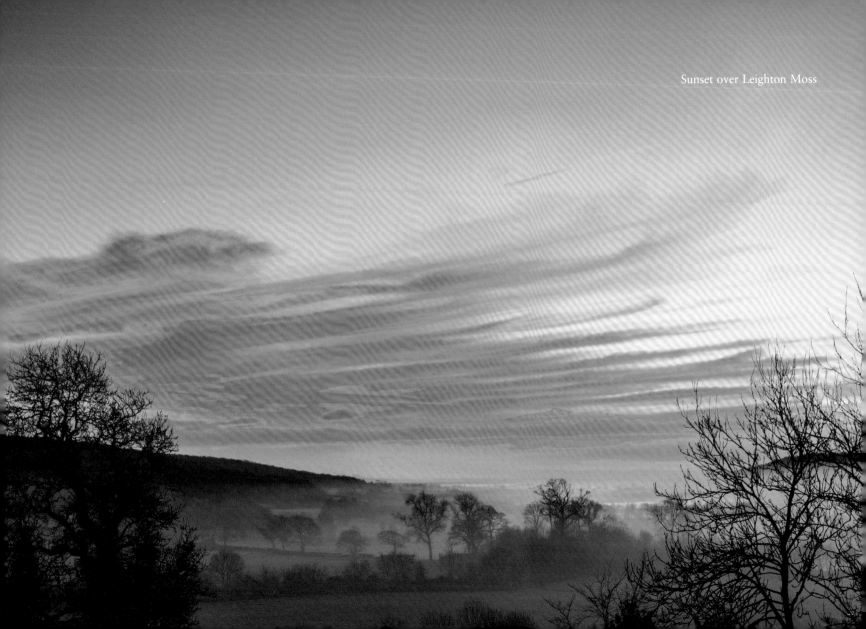

Sunset over Leighton Moss

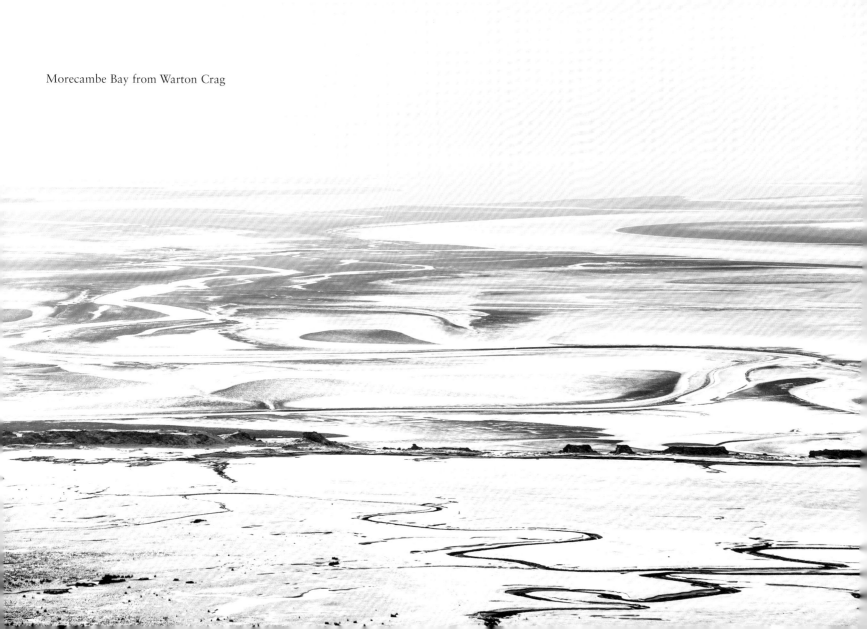

Morecambe Bay from Warton Crag

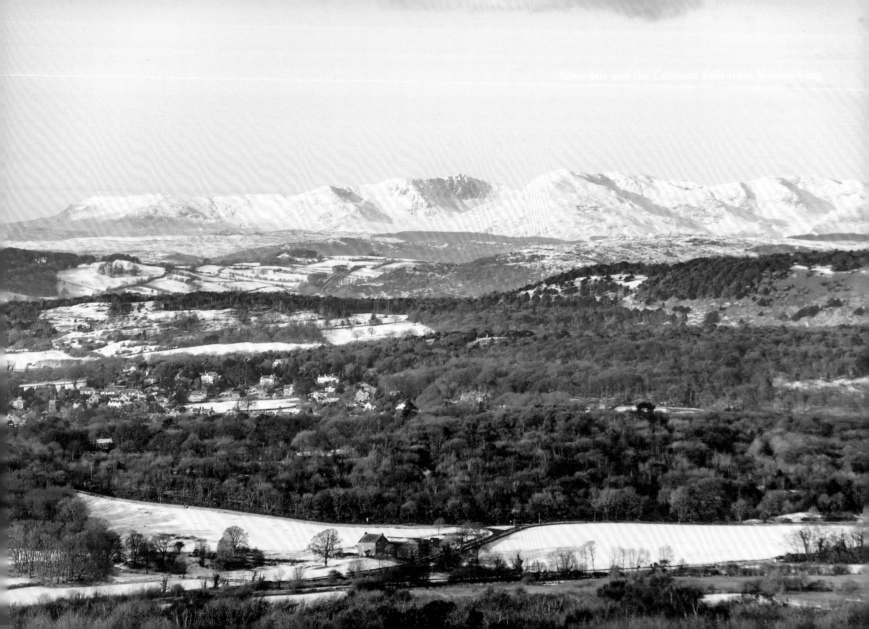

Silverdale and the Coniston Fells from Warton Crag

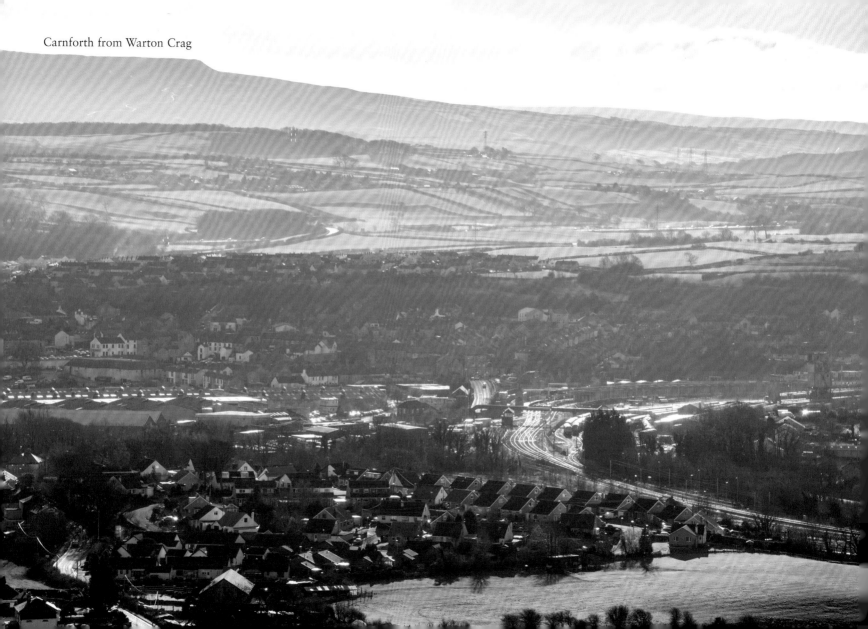

Carnforth from Warton Crag

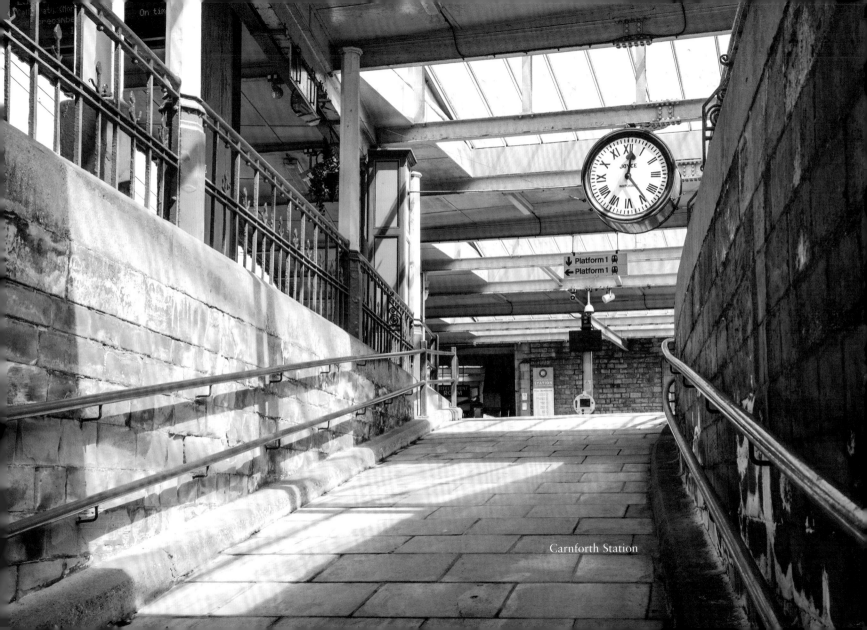

Carnforth Station

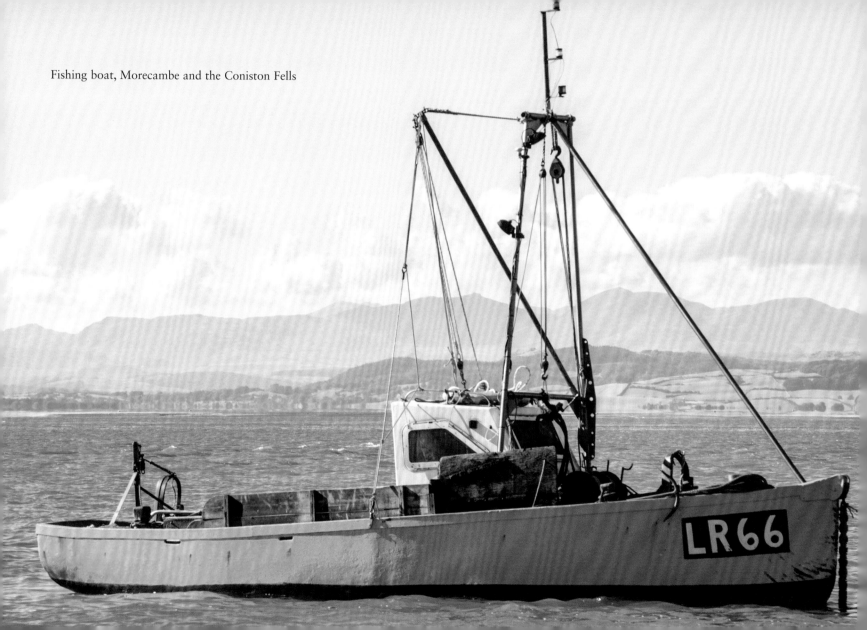

Fishing boat, Morecambe and the Coniston Fells

LR66

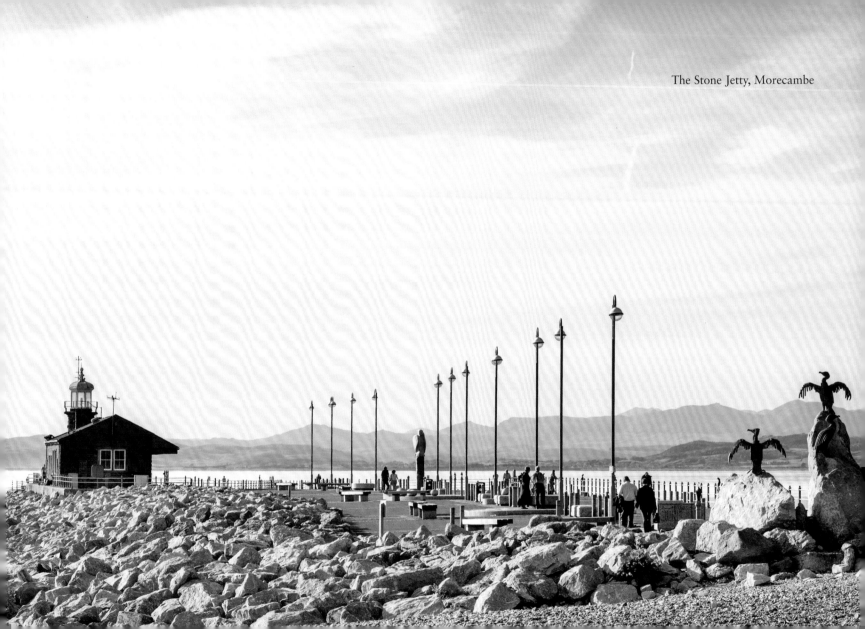

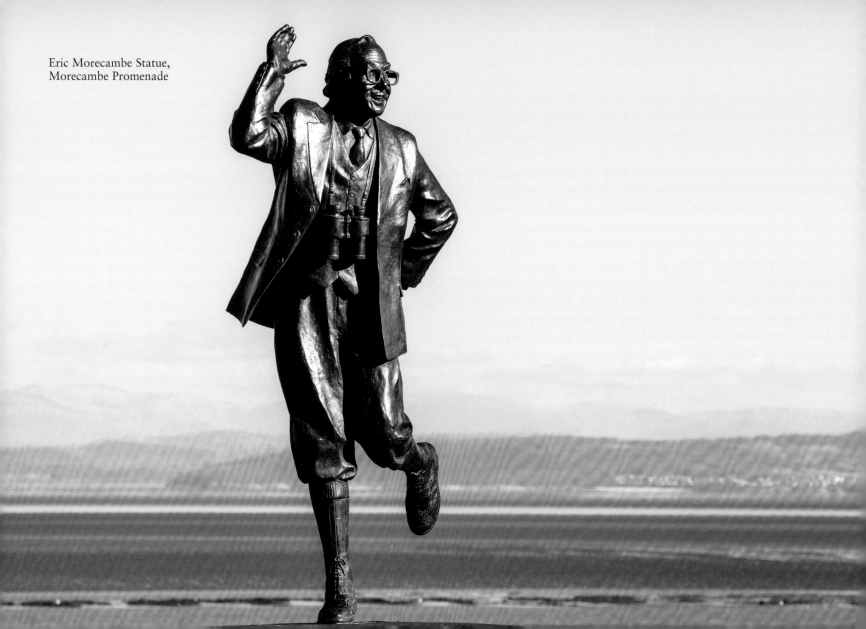

Eric Morecambe Statue,
Morecambe Promenade

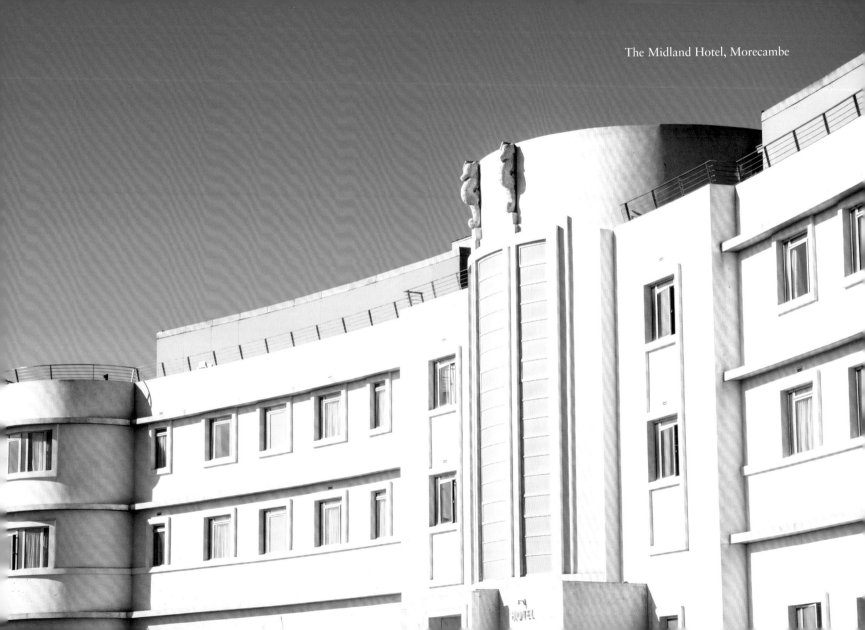

The Midland Hotel, Morecambe

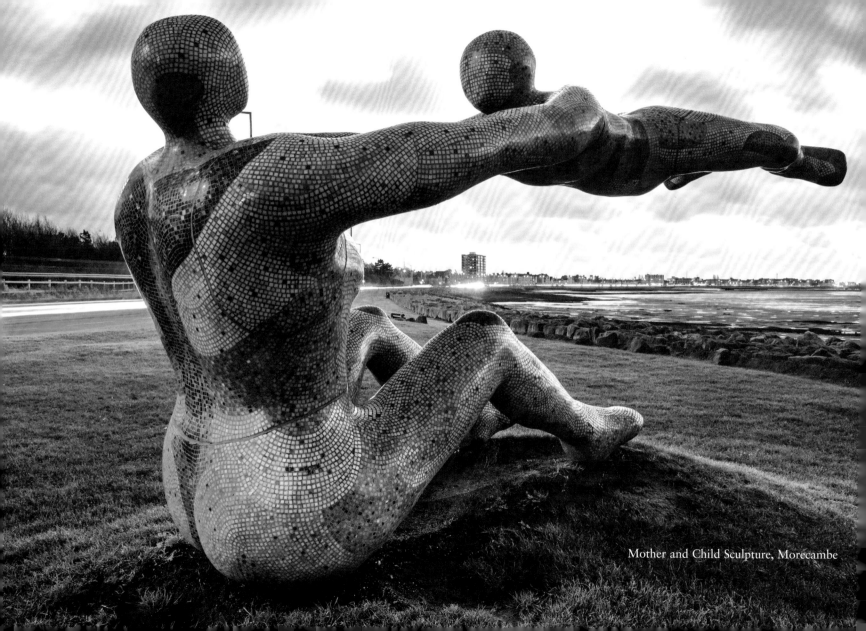
Mother and Child Sculpture, Morecambe

Standstone carving and St Patrick's Chapel, Heysham Head

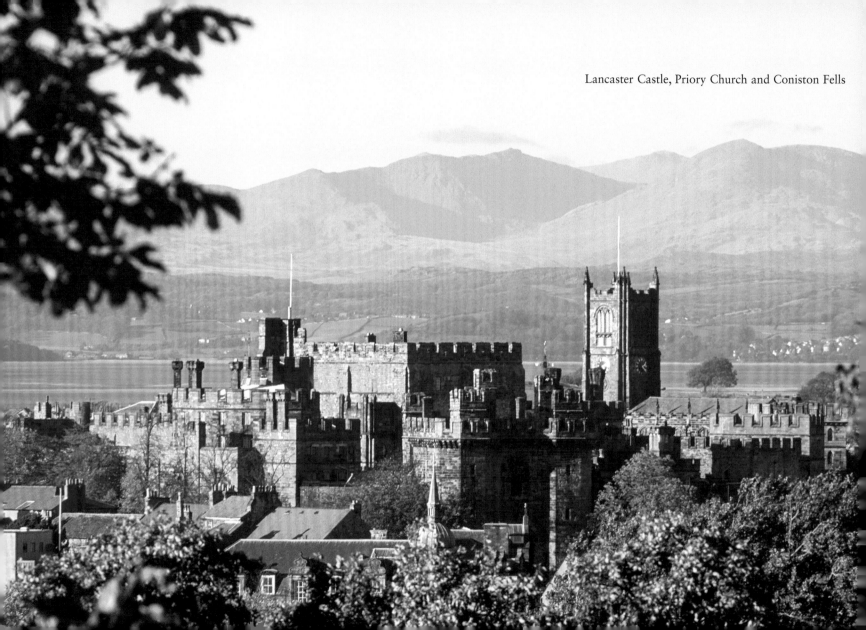

Lancaster Castle, Priory Church and Coniston Fells

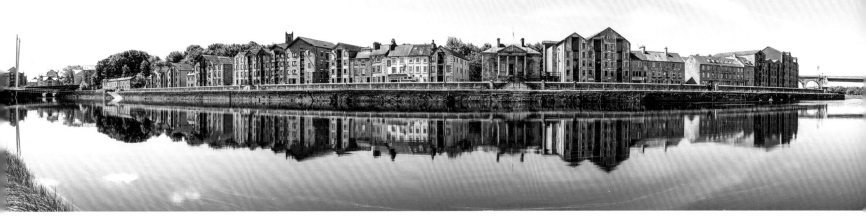

St George's Quay and the River Lune, Lancaster

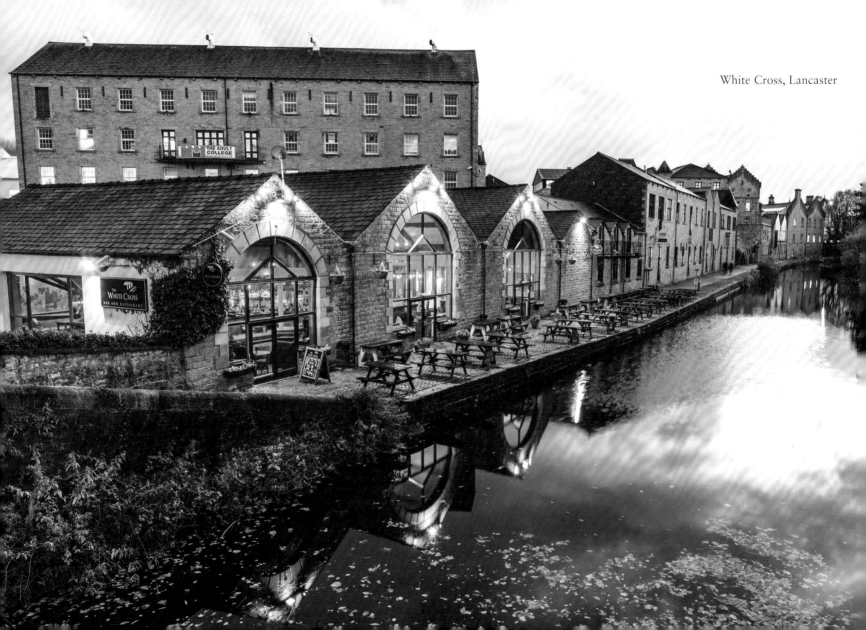

White Cross, Lancaster

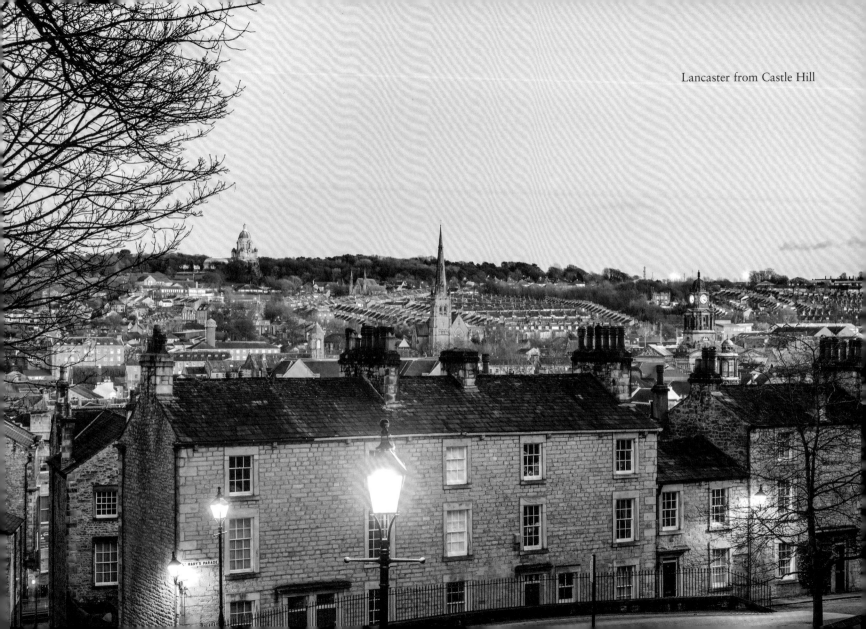

Lancaster from Castle Hill

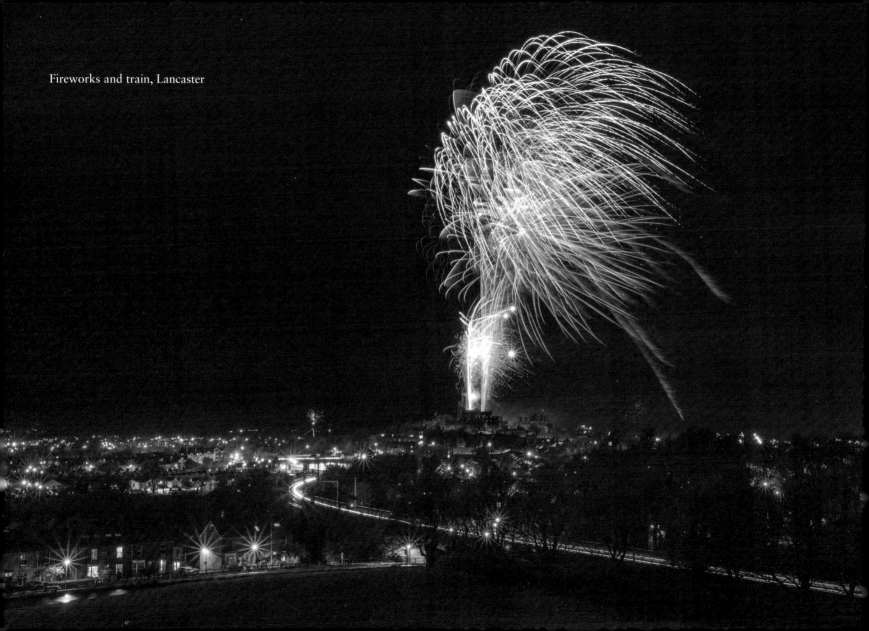

Fireworks and train, Lancaster

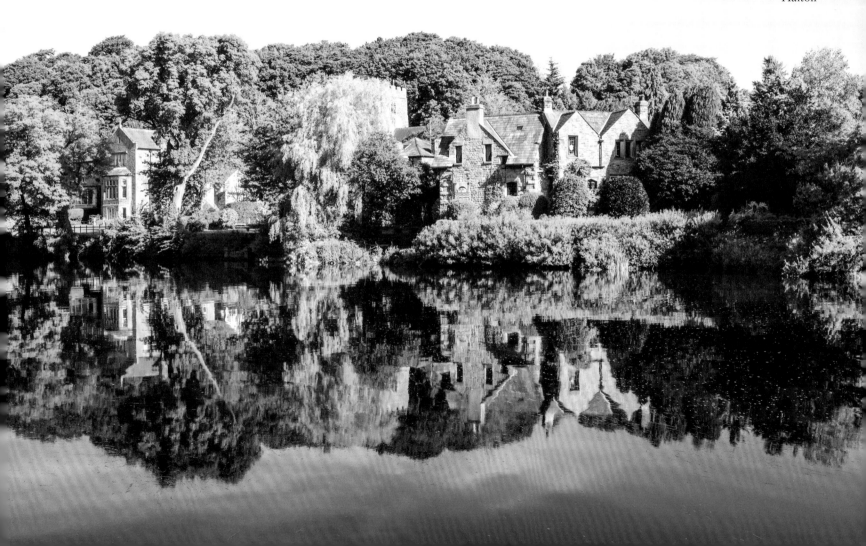

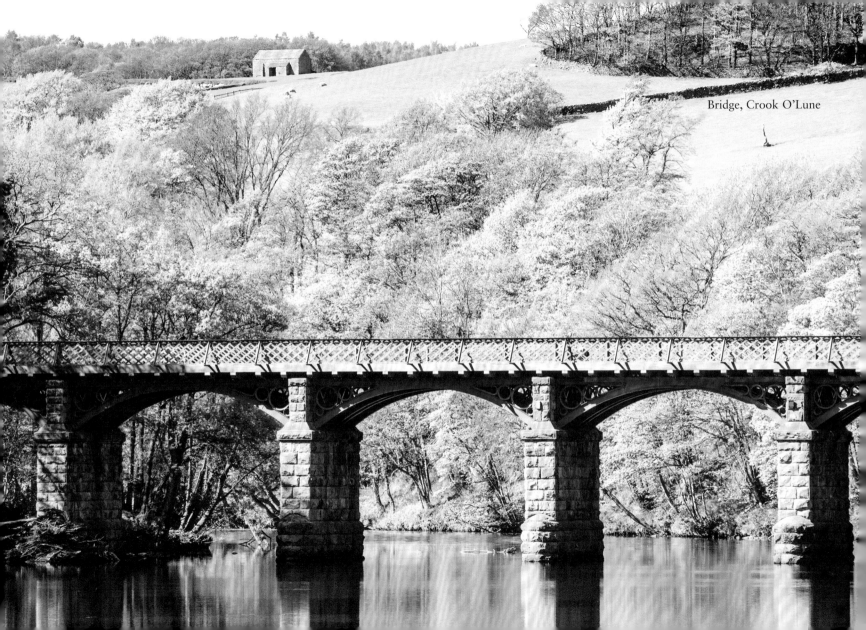

Bridge, Crook O'Lune

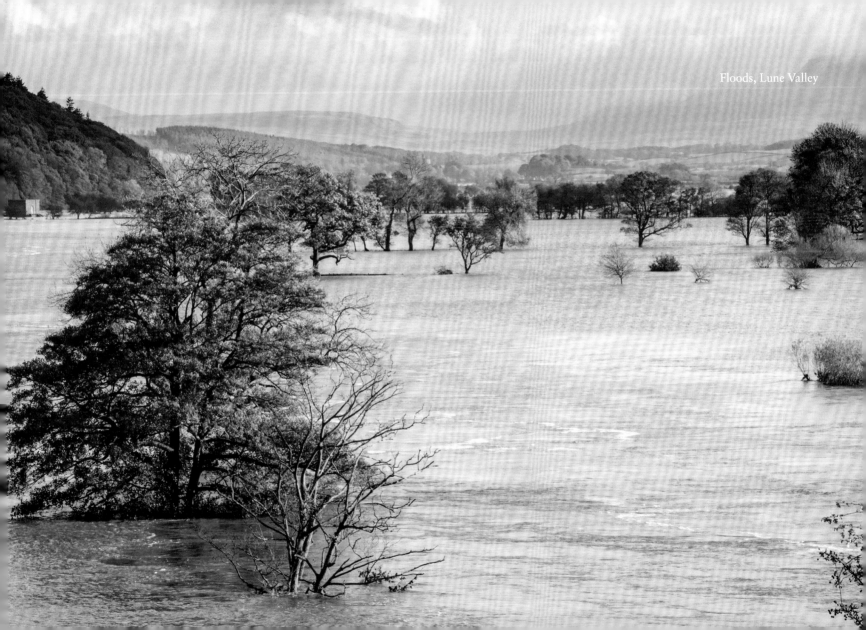

Floods, Lune Valley

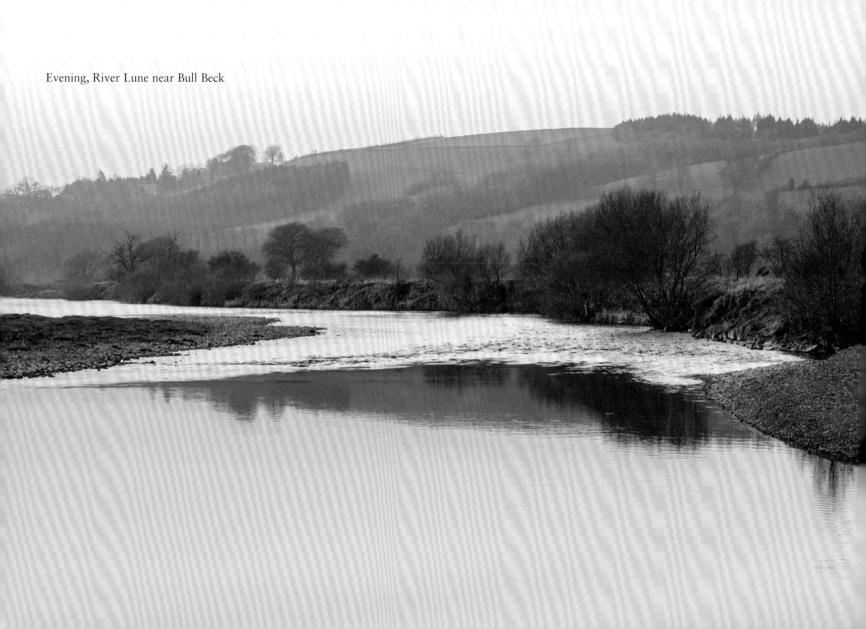

Evening, River Lune near Bull Beck

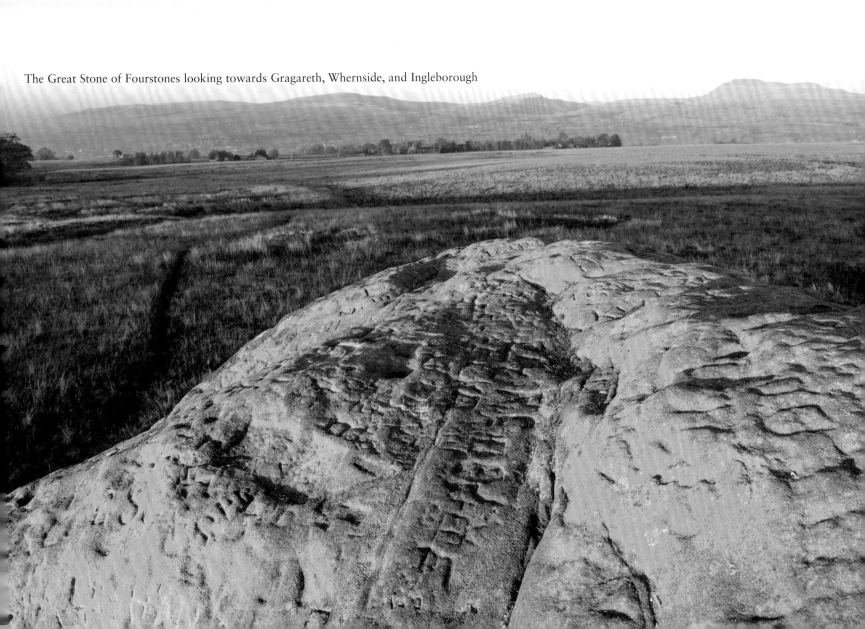

The Great Stone of Fourstones looking towards Gragareth, Whernside, and Ingleborough

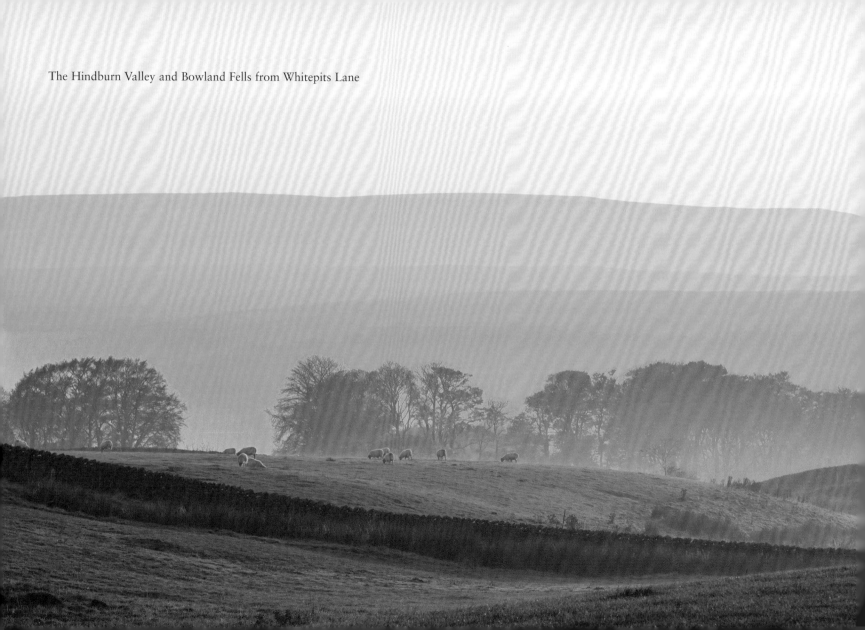

The Hindburn Valley and Bowland Fells from Whitepits Lane

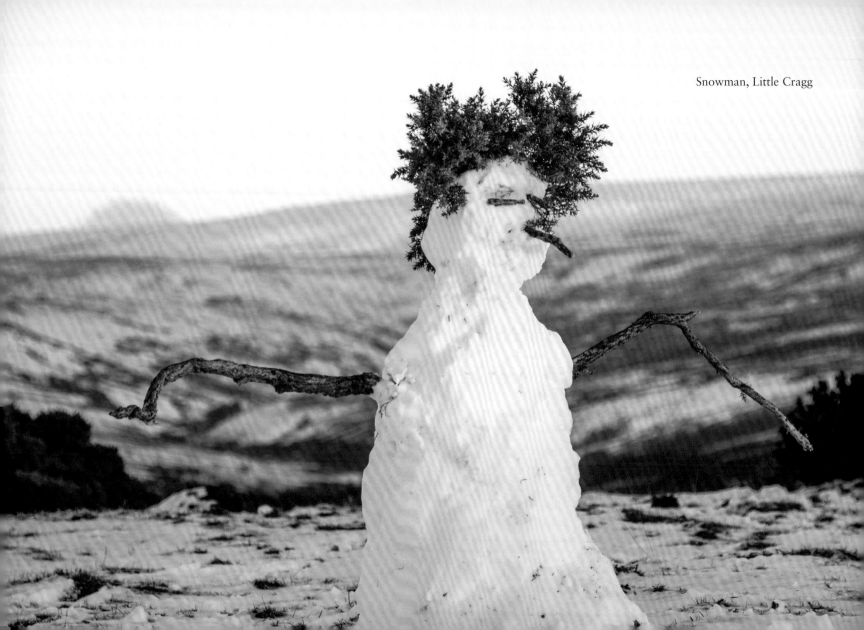

Snowman, Little Cragg

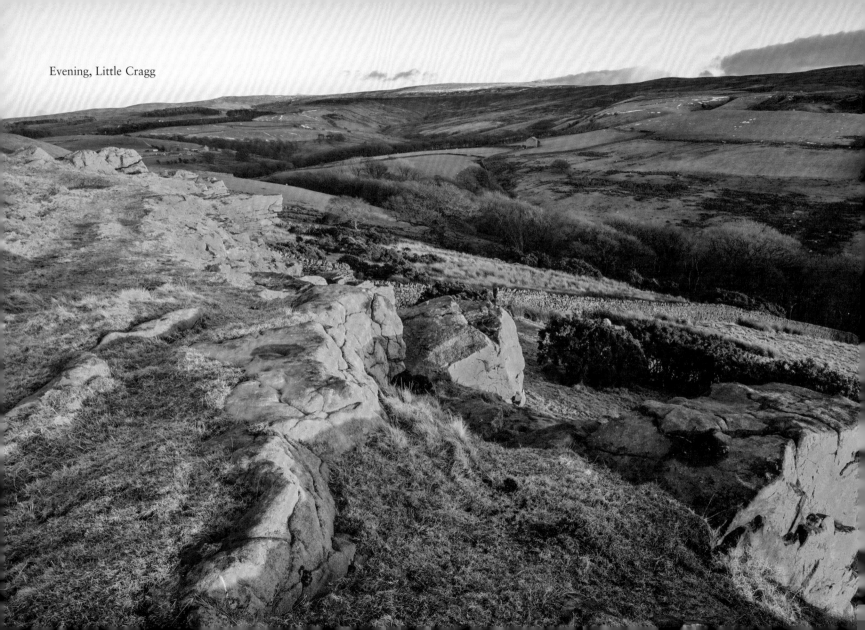

Evening, Little Cragg

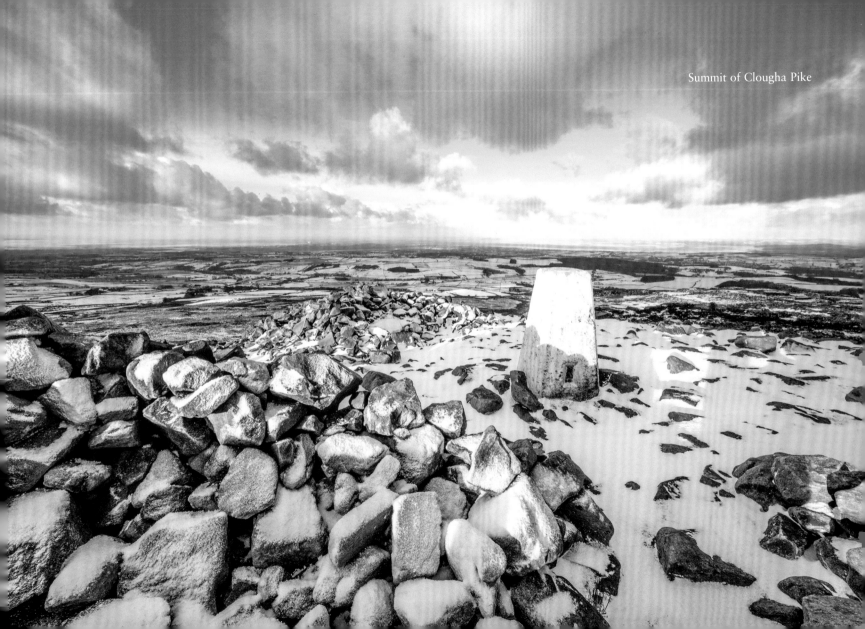

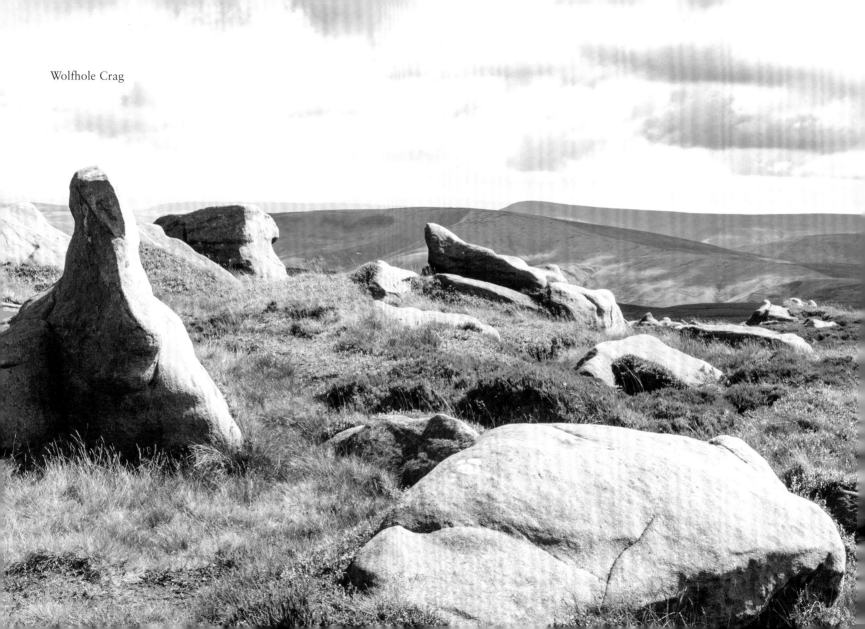

Wolfhole Crag

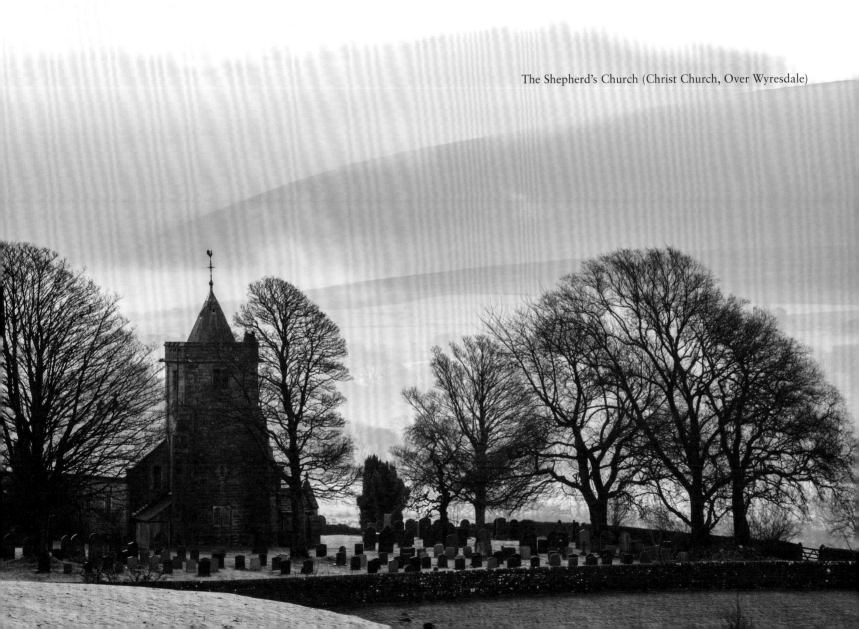

The Shepherd's Church (Christ Church, Over Wyresdale)

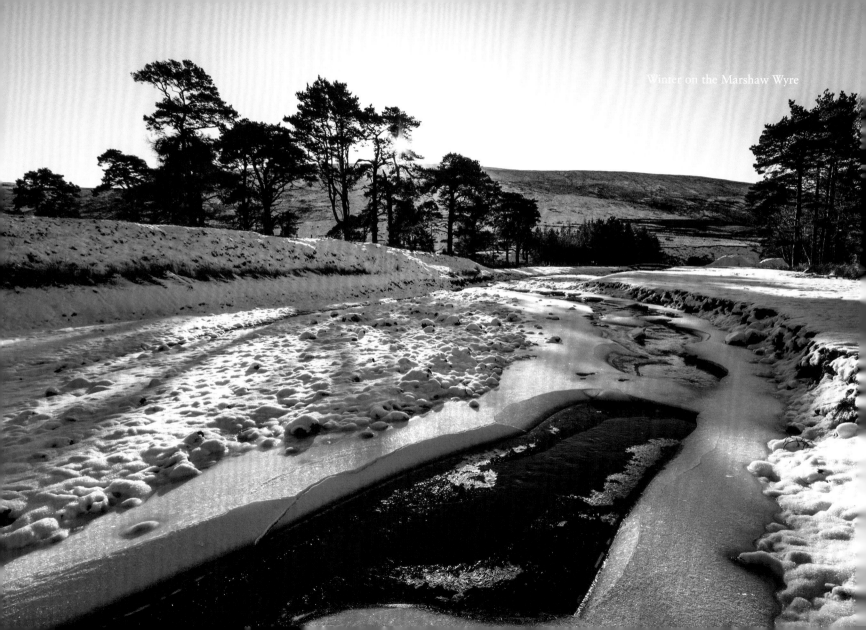

Winter on the Marshaw Wyre

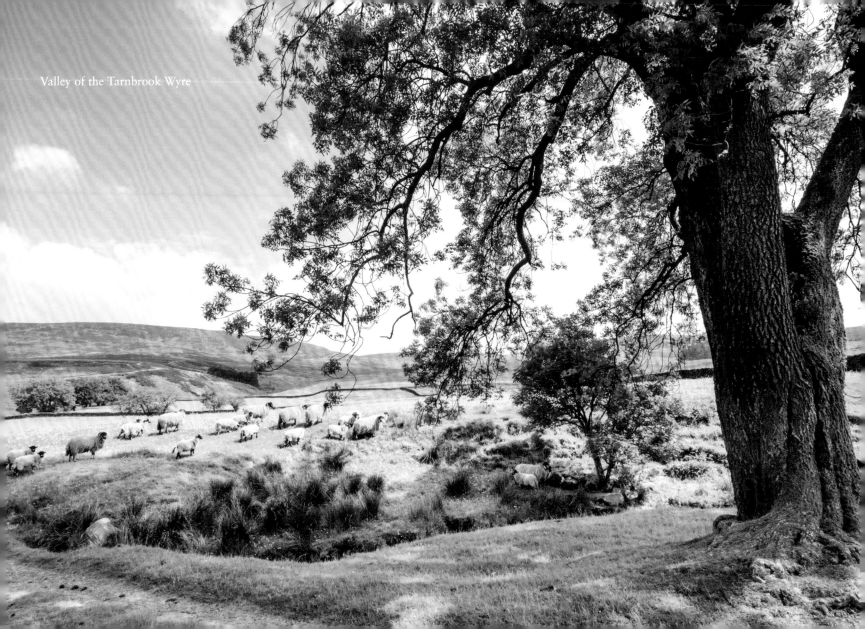

Valley of the Tarnbrook Wyre

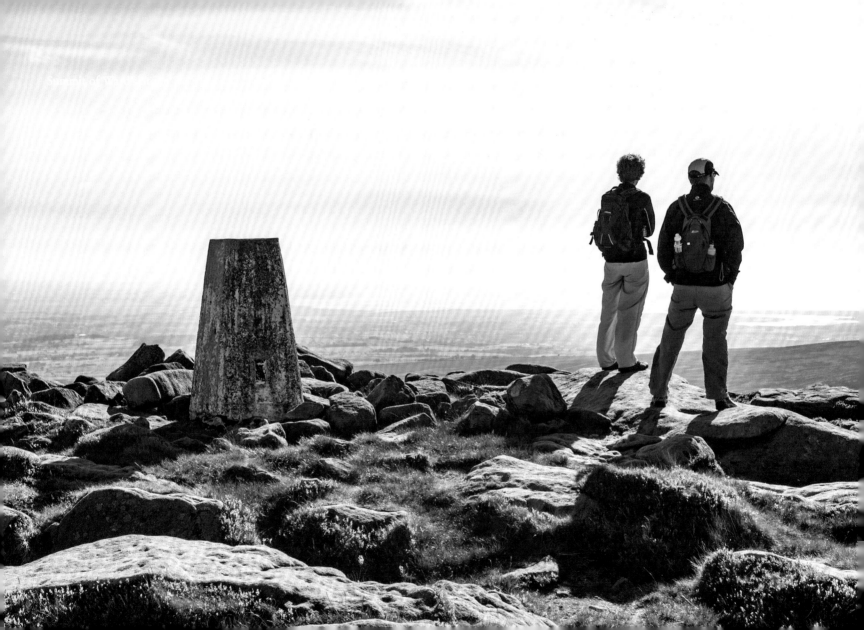

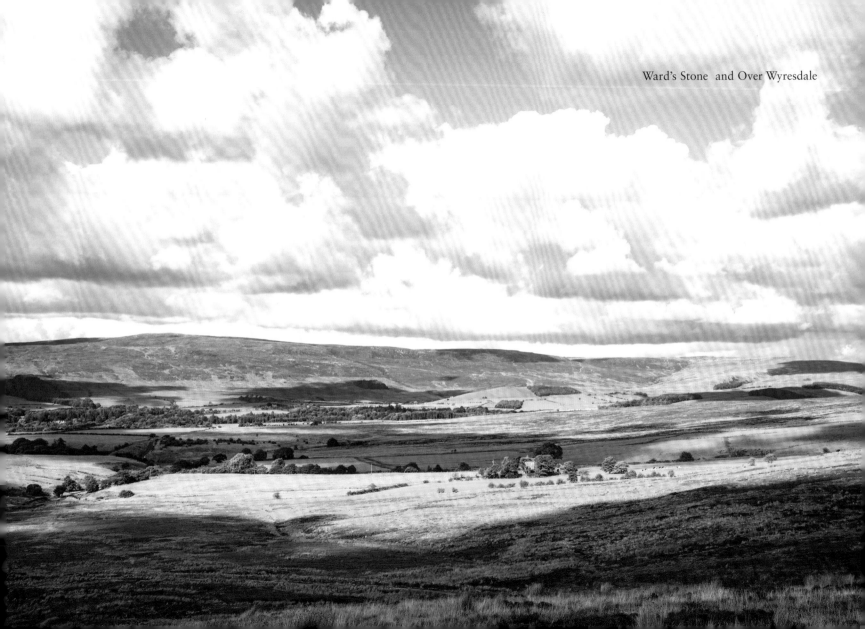

Ward's Stone and Over Wyresdale

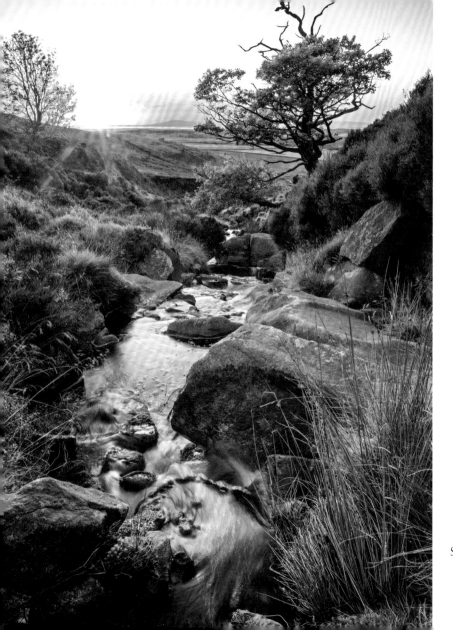

Sunset, Catshaw Greave, Hawthornthwaite Fell

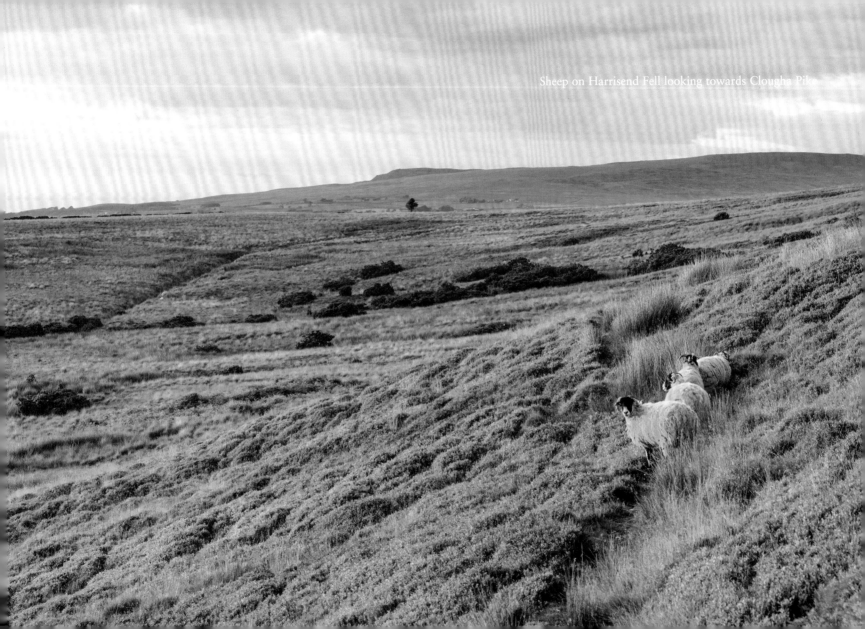

Sheep on Harrisend Fell looking towards Clougha Pike

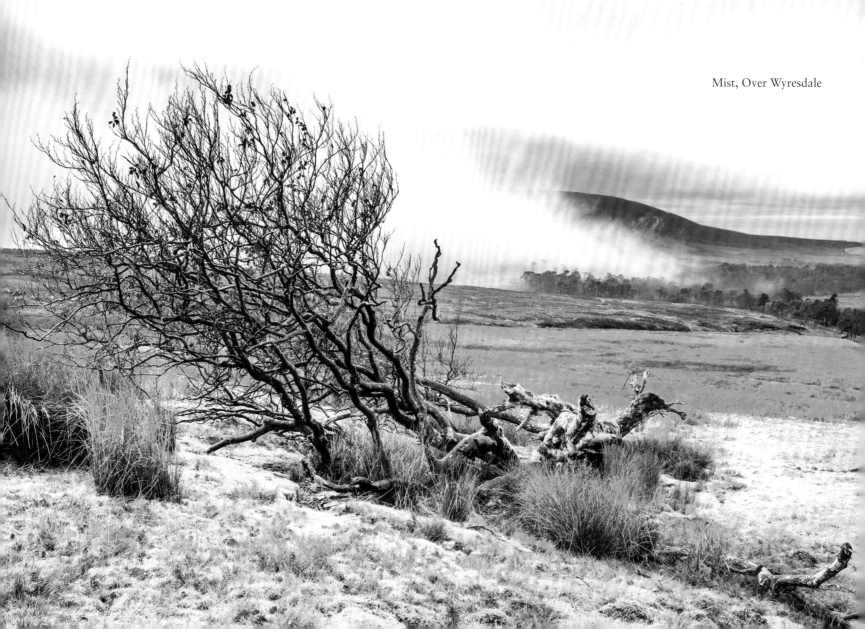

Mist, Over Wyresdale

Evening, Miller's House looking towards Whins Brow

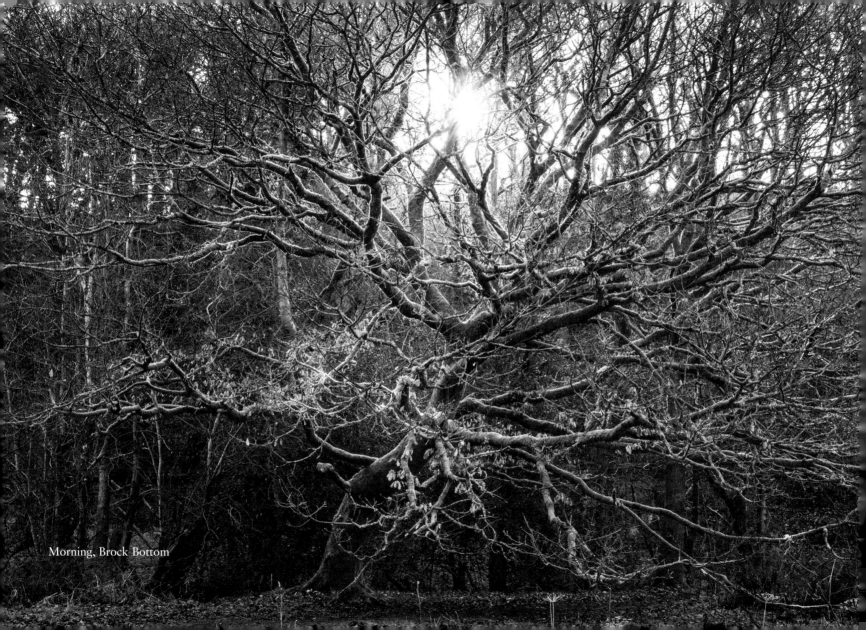

Morning, Brock Bottom

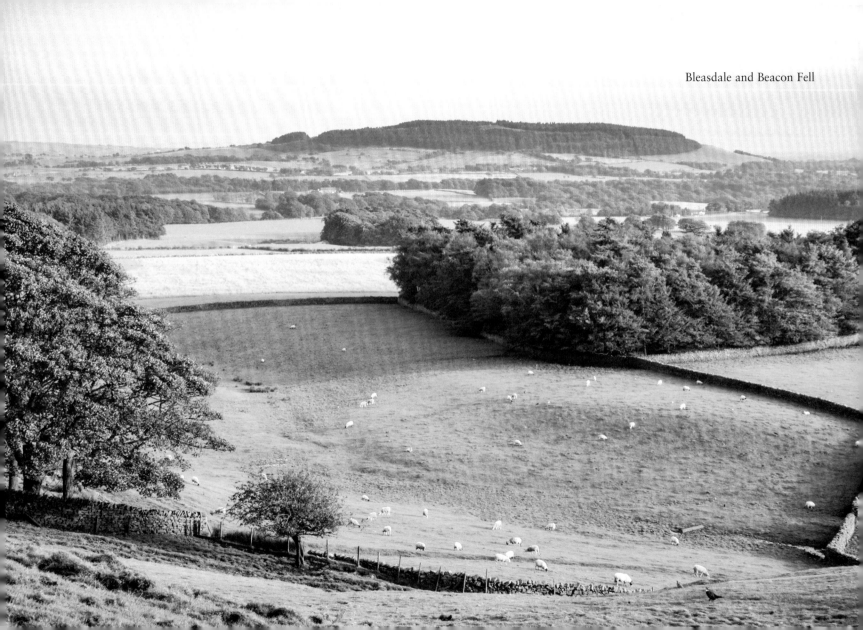

Bleasdale and Beacon Fell

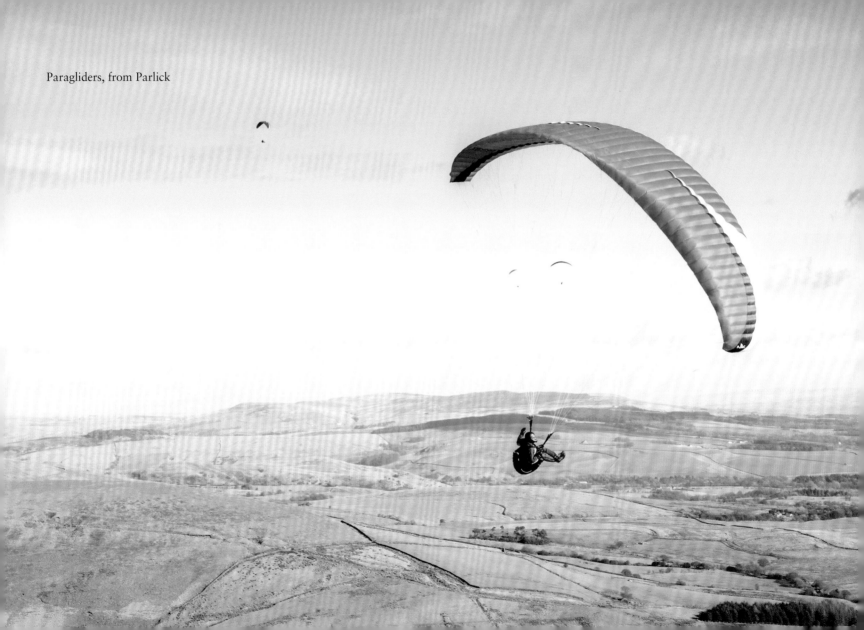

Paragliders, from Parlick

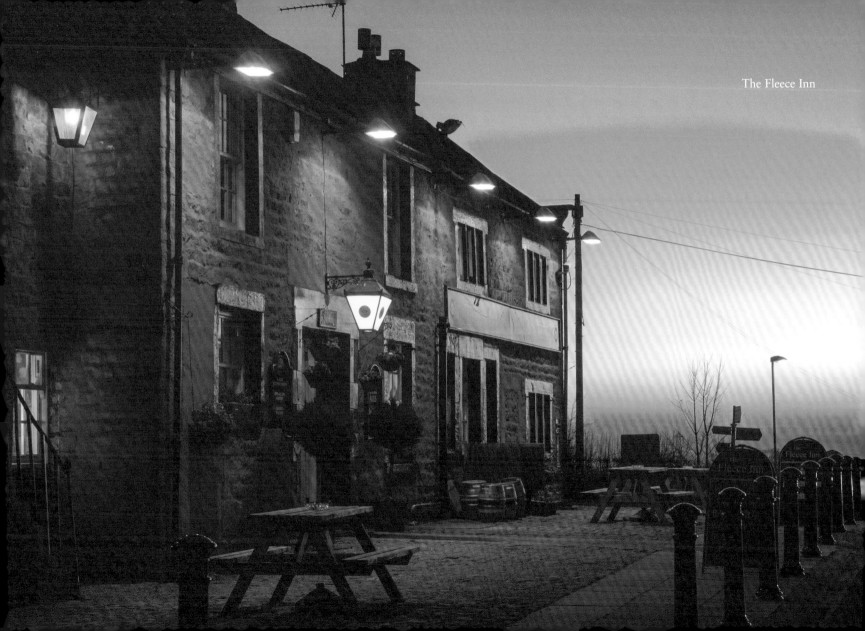

The Fleece Inn

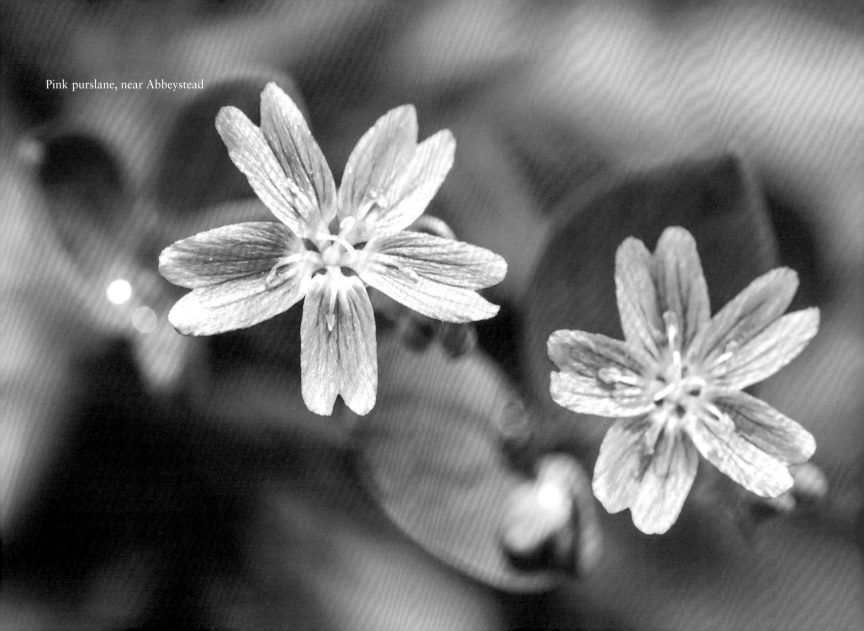

Pink purslane, near Abbeystead

The Loud Valley and Bowland Fells from Jeffrey Hill

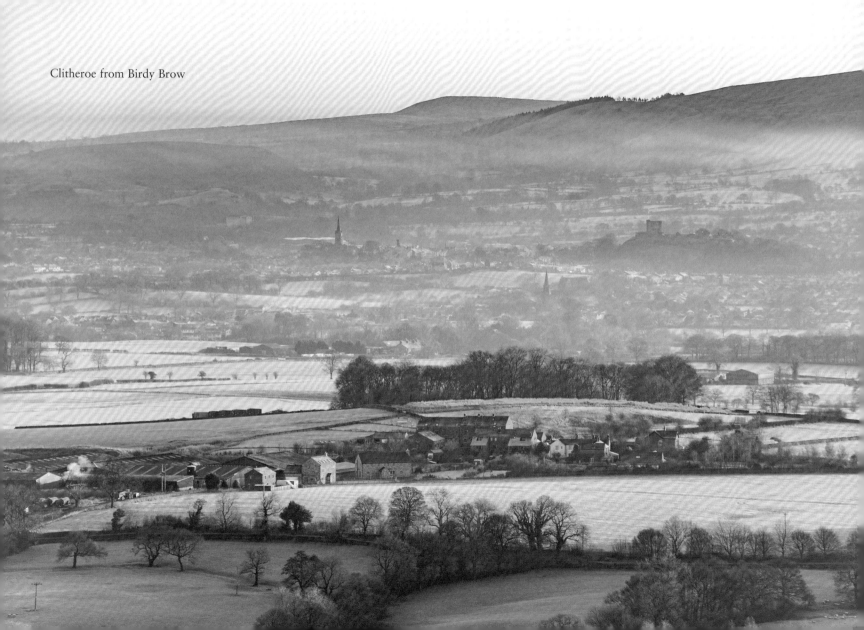

Clitheroe from Birdy Brow

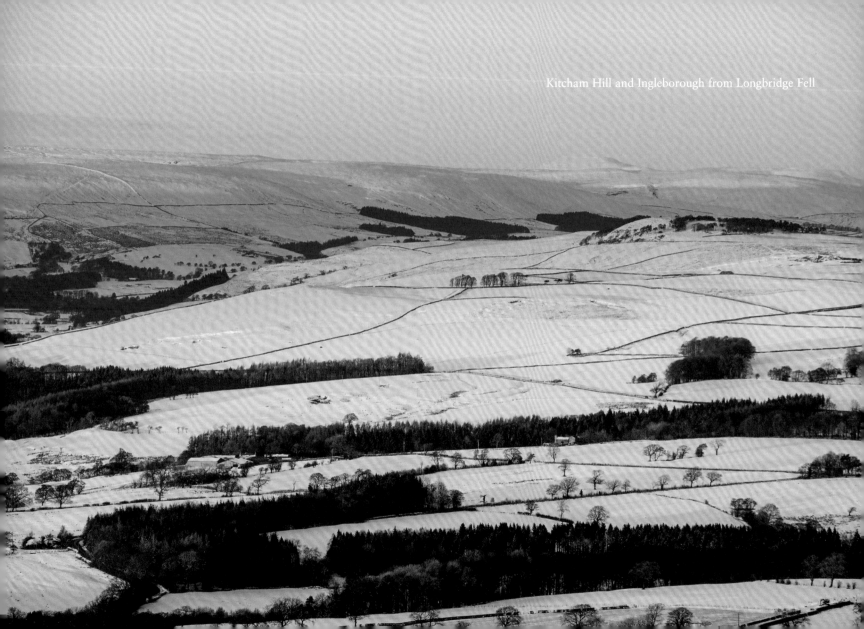

Kitcham Hill and Ingleborough from Longbridge Fell

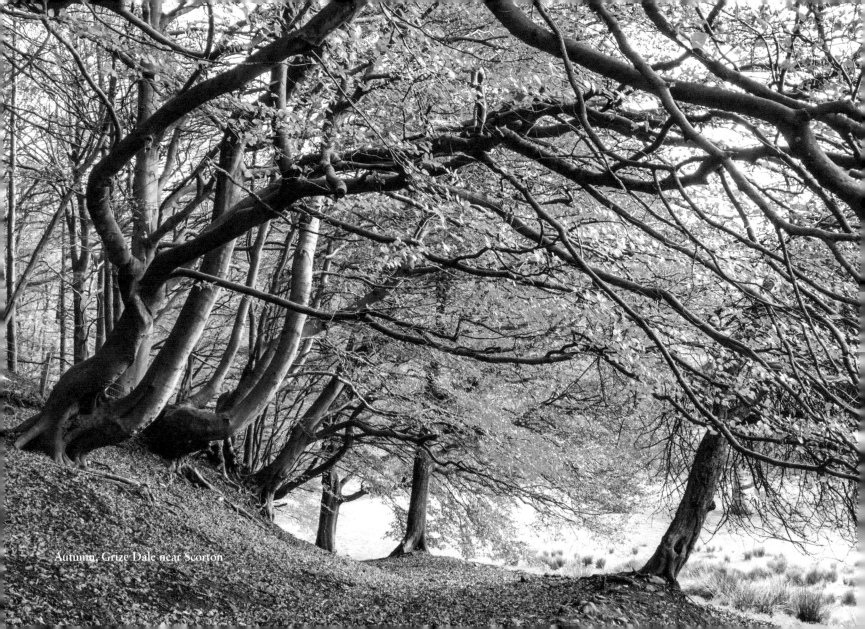

Autumn, Grize Dale near Scorton

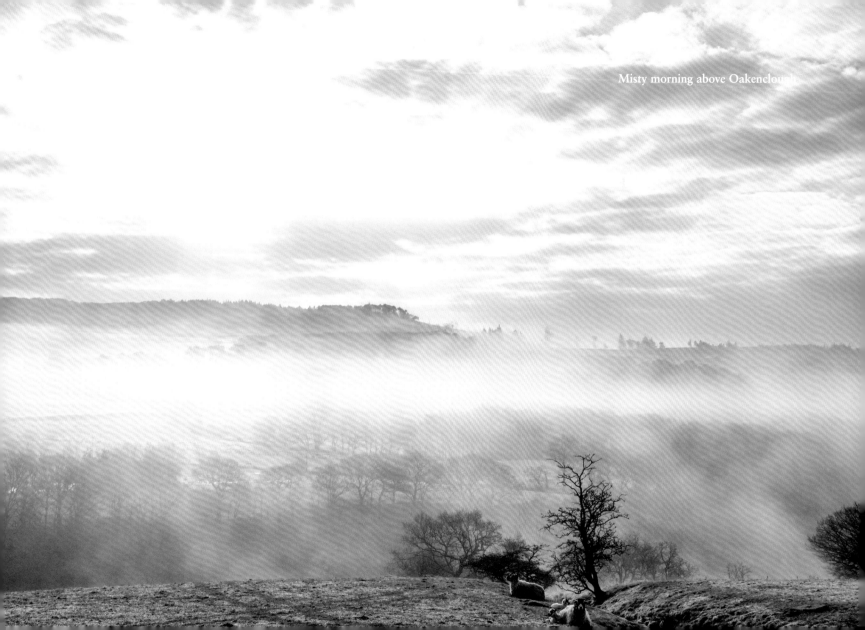

Misty morning above Oakenclough

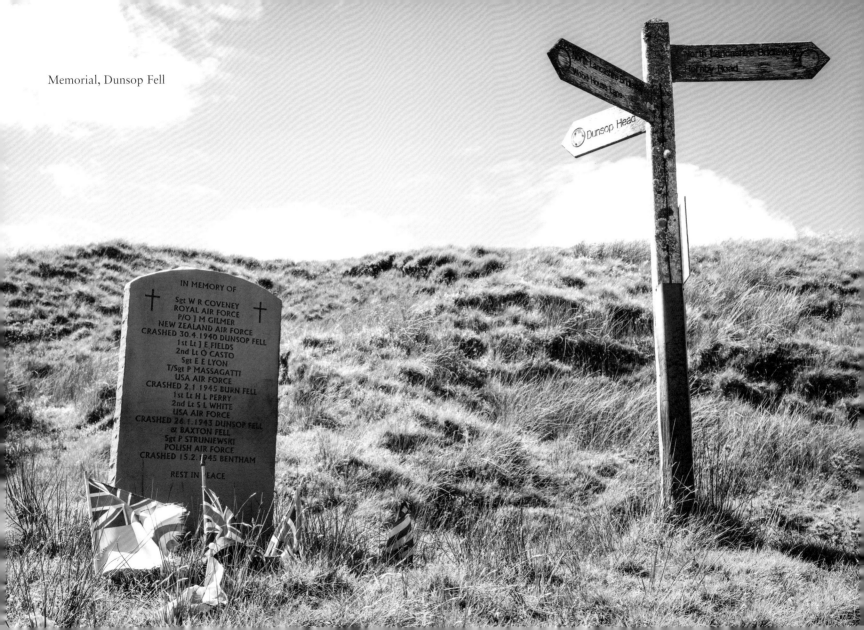

Memorial, Dunsop Fell

IN MEMORY OF

Sgt W R COVENEY
ROYAL AIR FORCE
P/O J M GILMER
NEW ZEALAND AIR FORCE
CRASHED 30.4.1940 DUNSOP FELL
1st Lt J E FIELDS
2nd Lt O CASTO
Sgt E E LYON
T/Sgt P MASSAGATTI
USA AIR FORCE
CRASHED 2.1 1945 BURN FELL
1st Lt H L PERRY
2nd Lt S L WHITE
USA AIR FORCE
CRASHED 26.1.1943 DUNSOP FELL
& BAXTON FELL
Sgt P STRUNIEWSKI
POLISH AIR FORCE
CRASHED 15.2 1945 BENTHAM

REST IN PEACE

North Lancashire Bridleway
Wood House Lane

North Lancashire Bridleway
Hornby Road

Dunsop Head

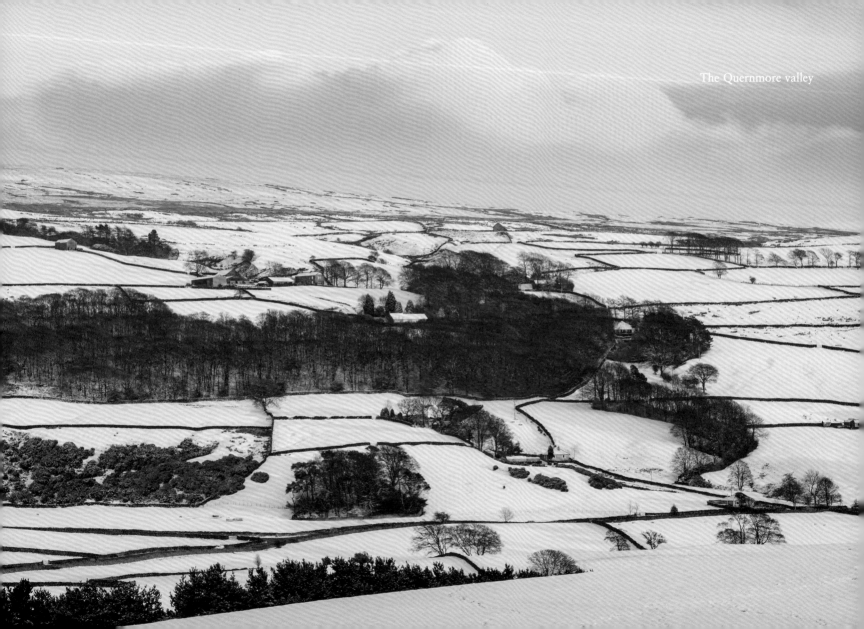

The Quernmore valley

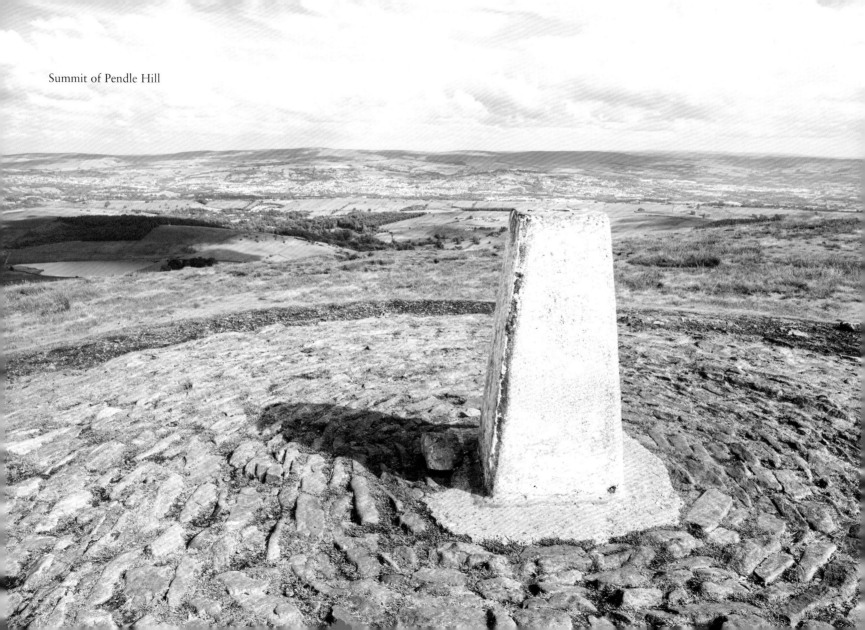

Summit of Pendle Hill

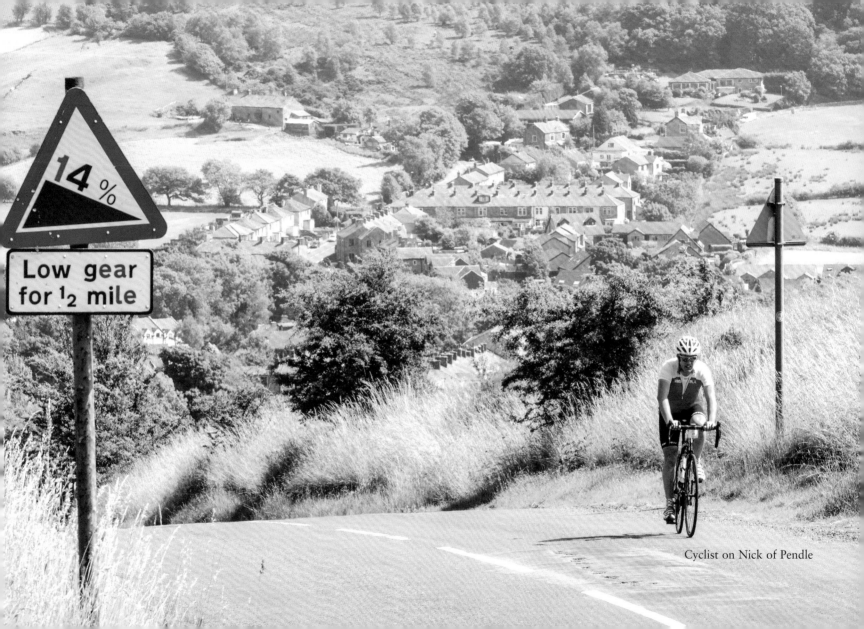

14 %

Low gear
for 1/2 mile

Cyclist on Nick of Pendle

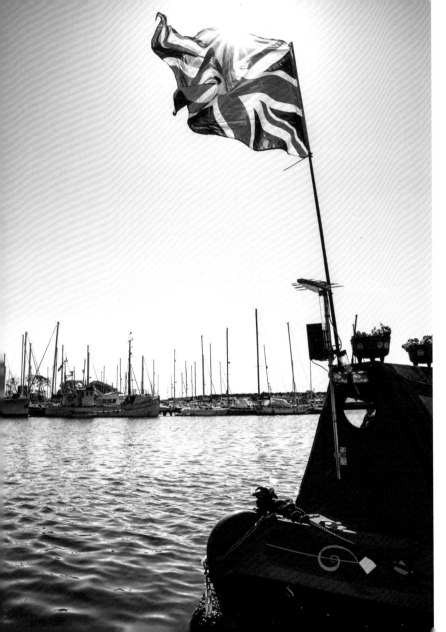

Inner basin, Glasson Dock

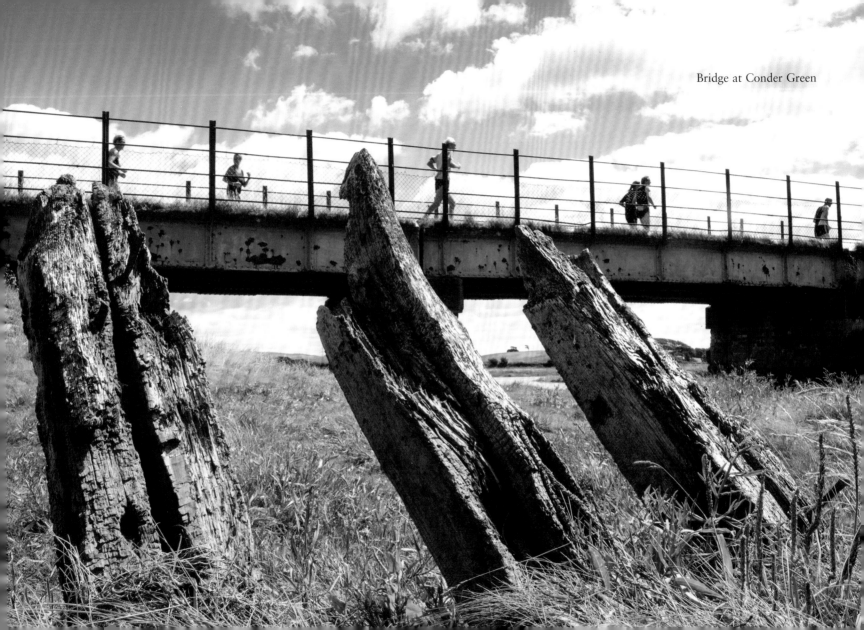
Bridge at Conder Green

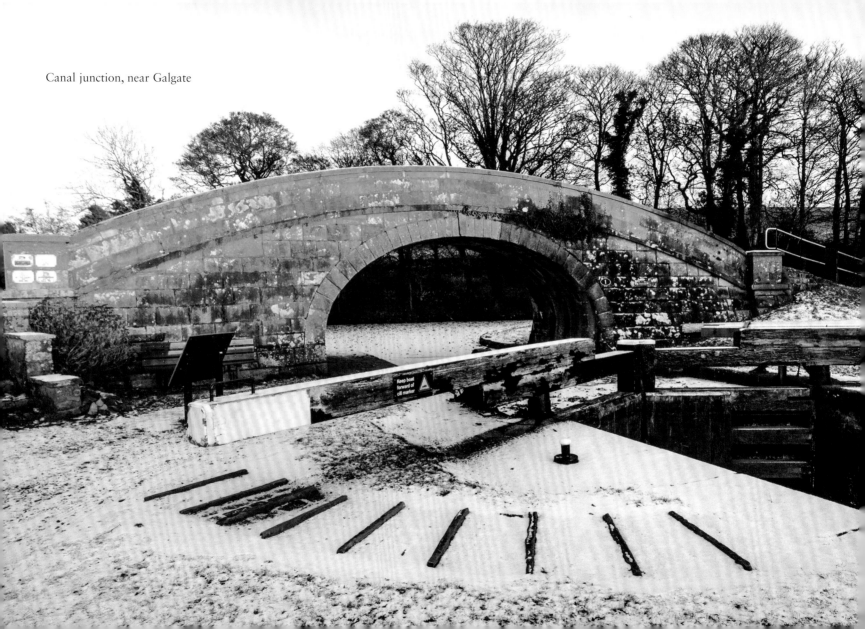

Canal junction, near Galgate

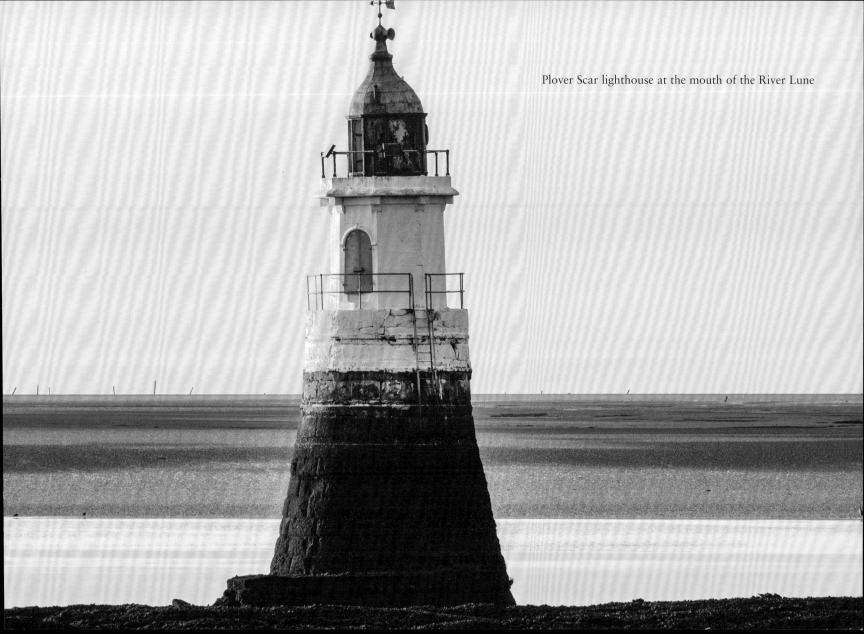

Plover Scar lighthouse at the mouth of the River Lune

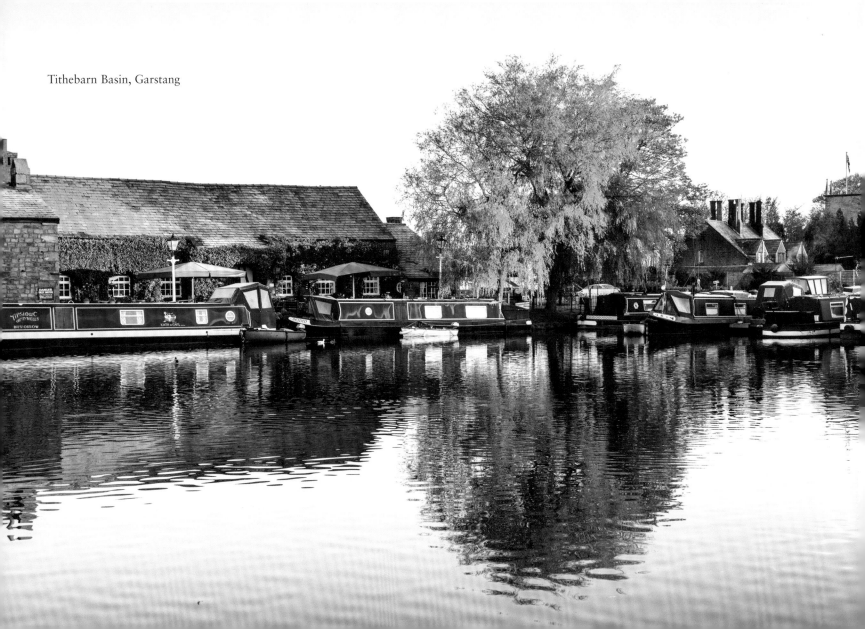

Tithebarn Basin, Garstang

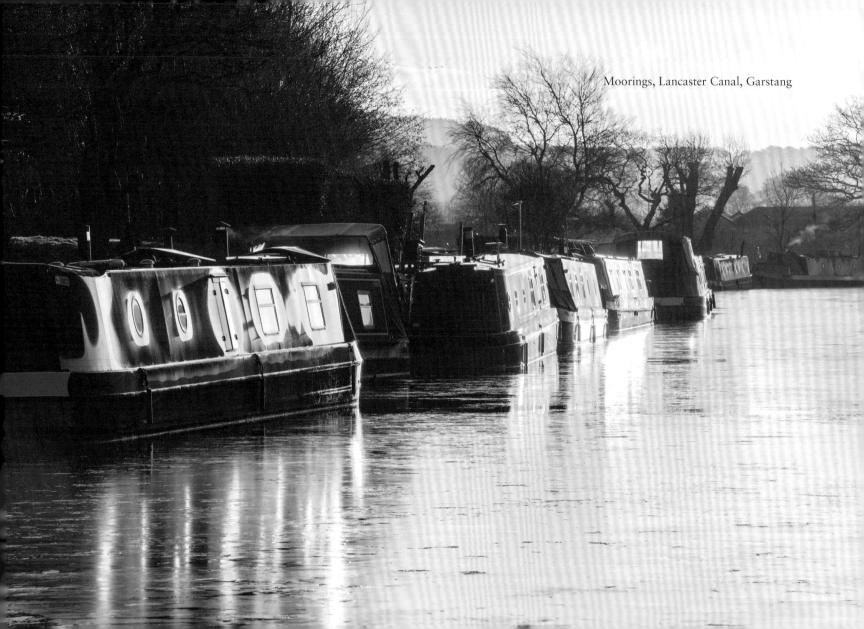

Moorings, Lancaster Canal, Garstang

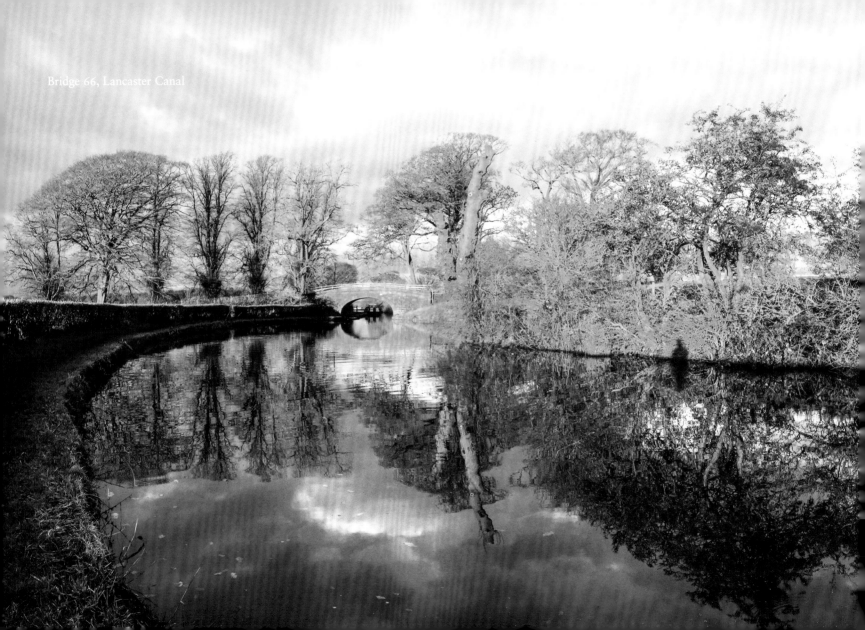

Bridge 66, Lancaster Canal

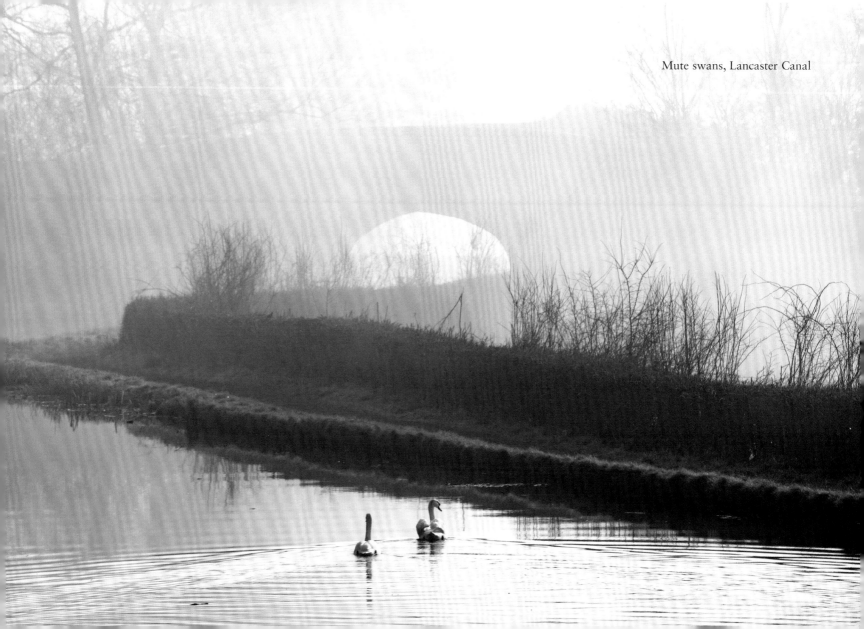

Mute swans, Lancaster Canal

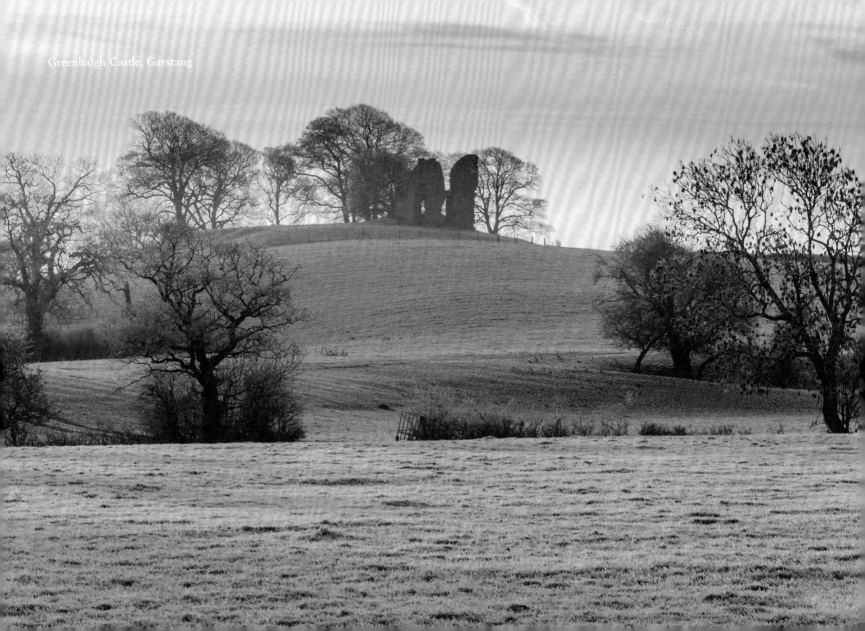
Greenhalgh Castle, Garstang

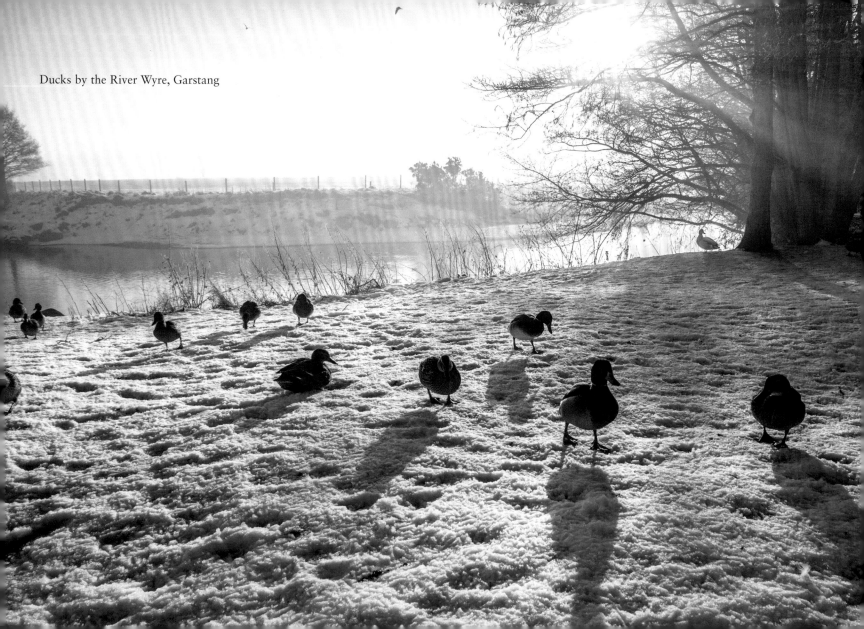

Ducks by the River Wyre, Garstang

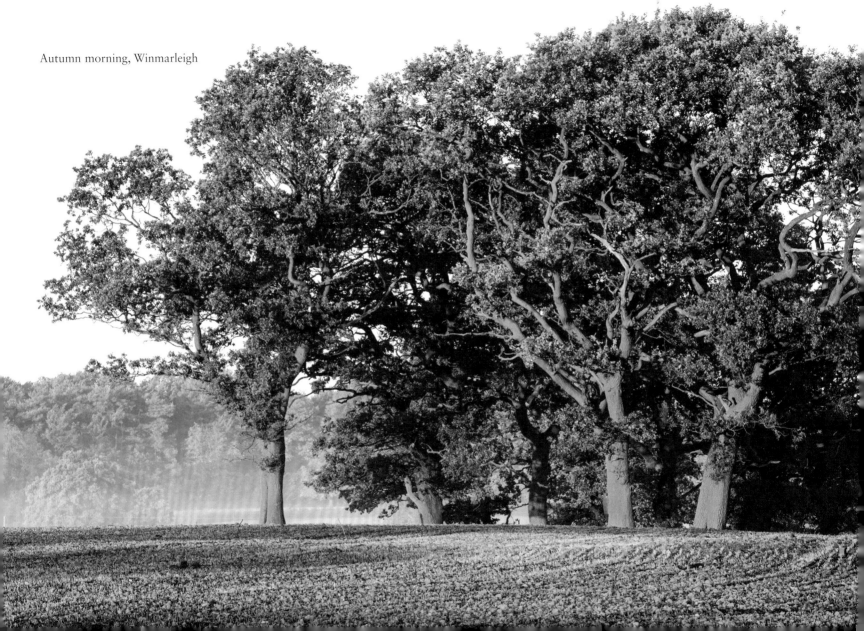

Autumn morning, Winmarleigh

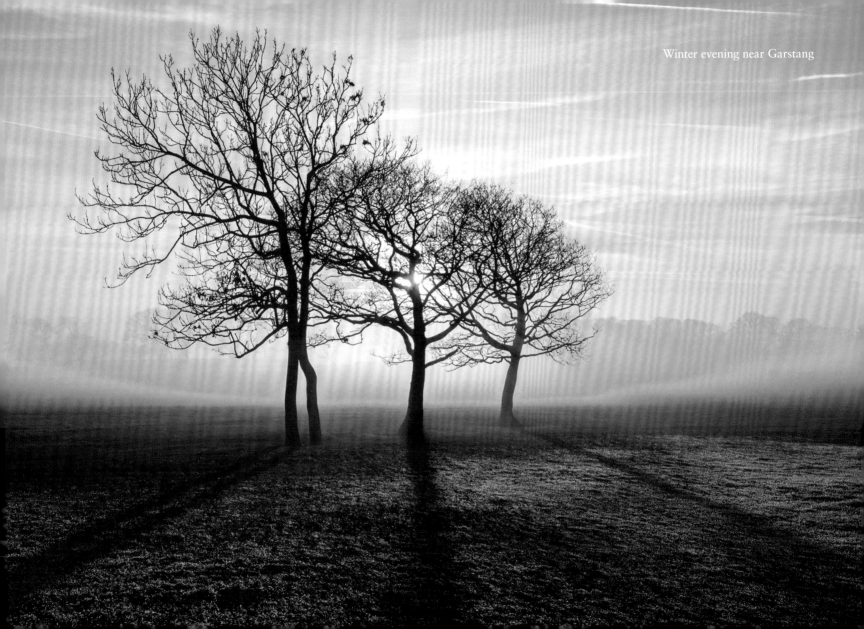

Winter evening near Garstang

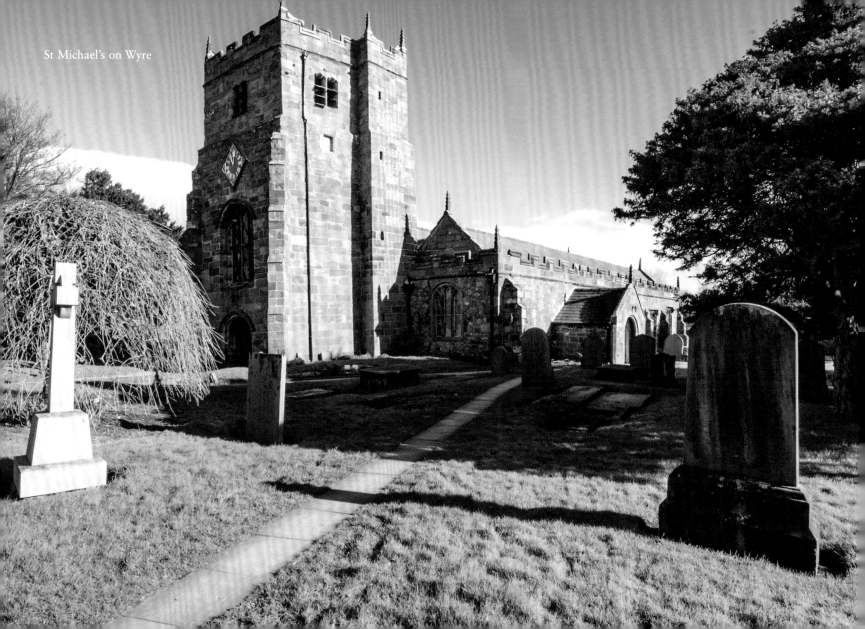

St Michael's on Wyre

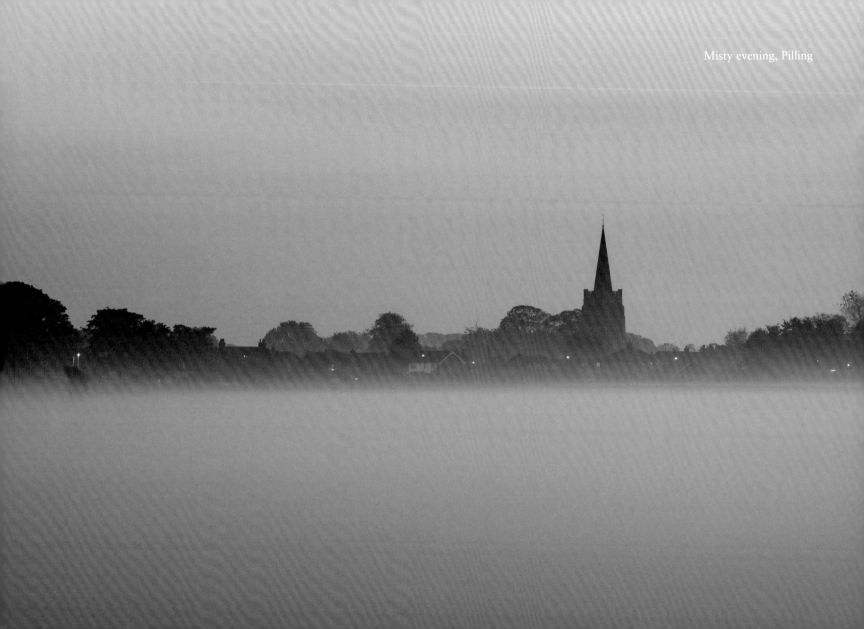

Misty evening, Pilling

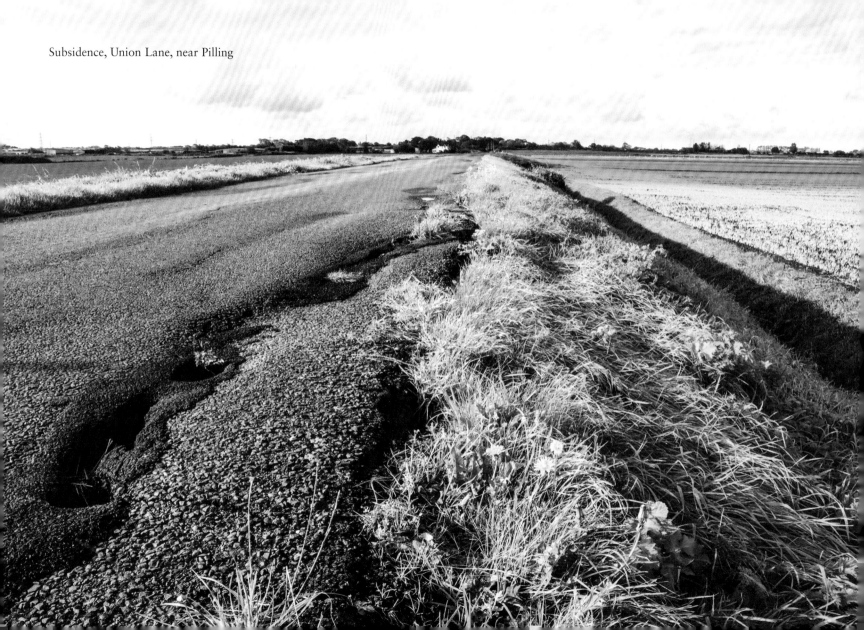

Subsidence, Union Lane, near Pilling

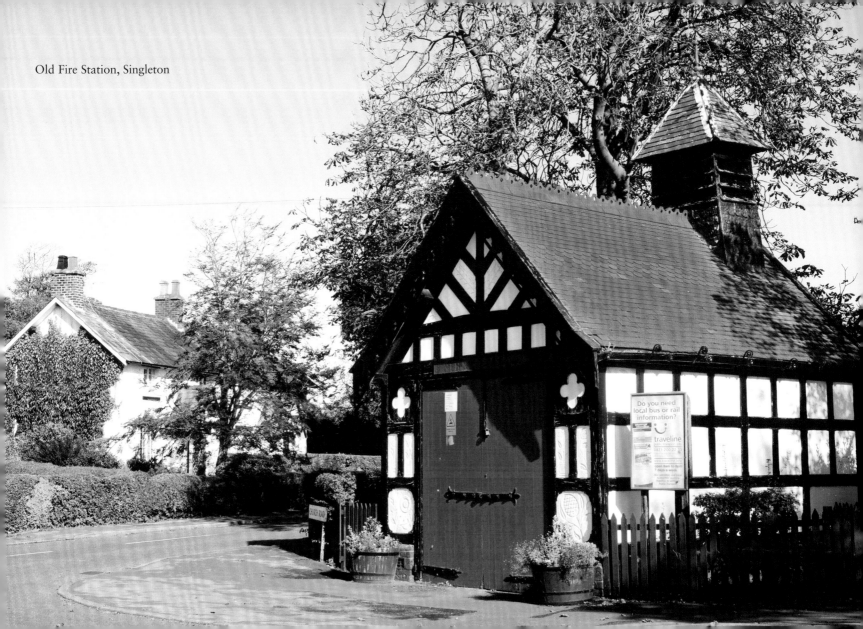

Old Fire Station, Singleton

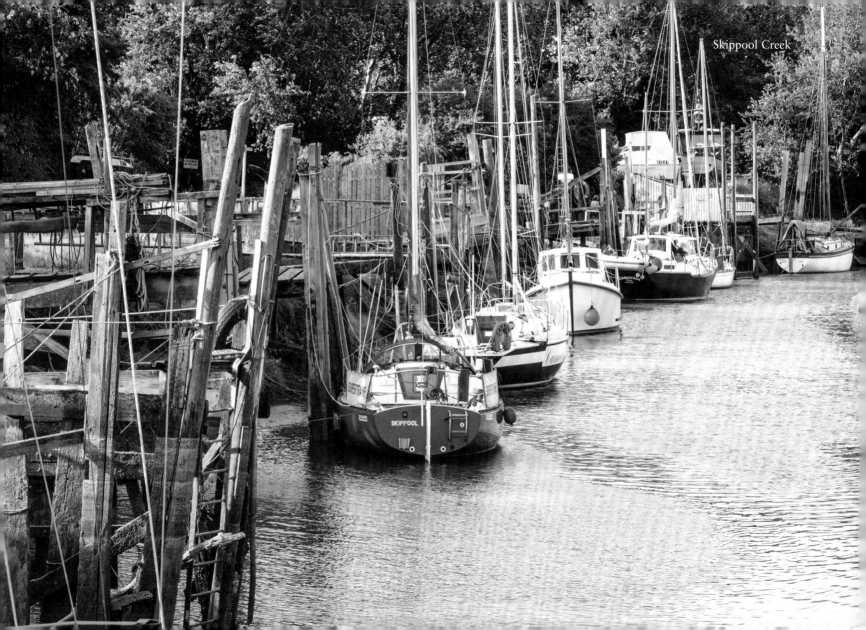

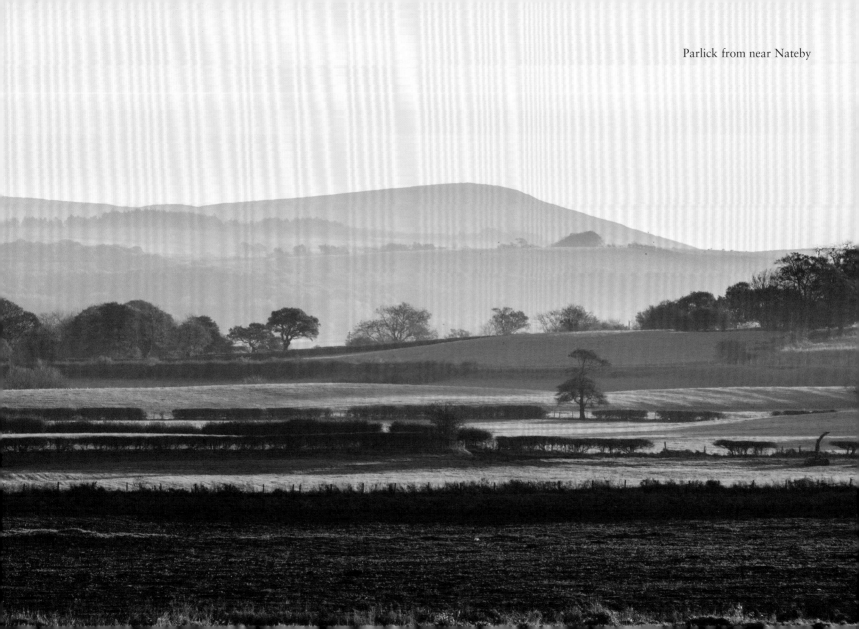

Parlick from near Nateby

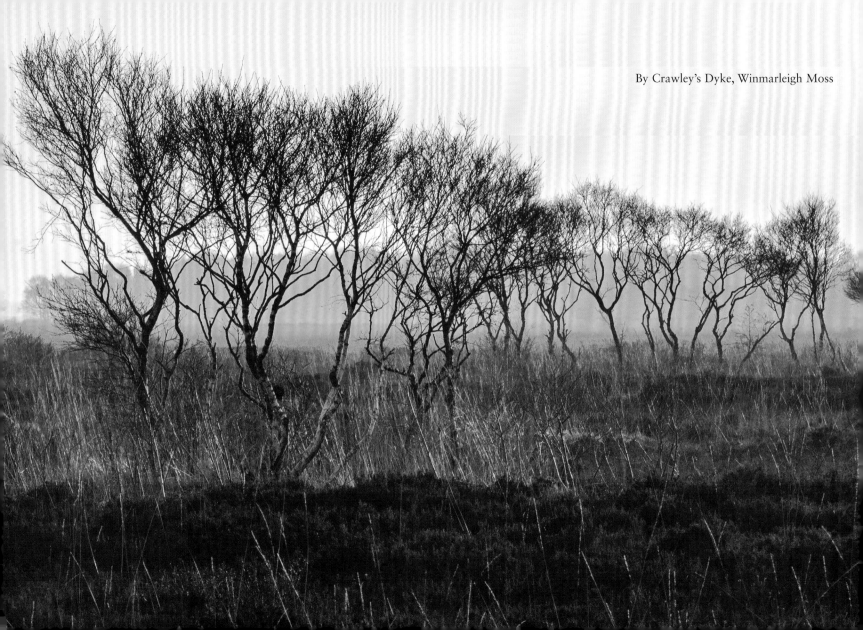

By Crawley's Dyke, Winmarleigh Moss

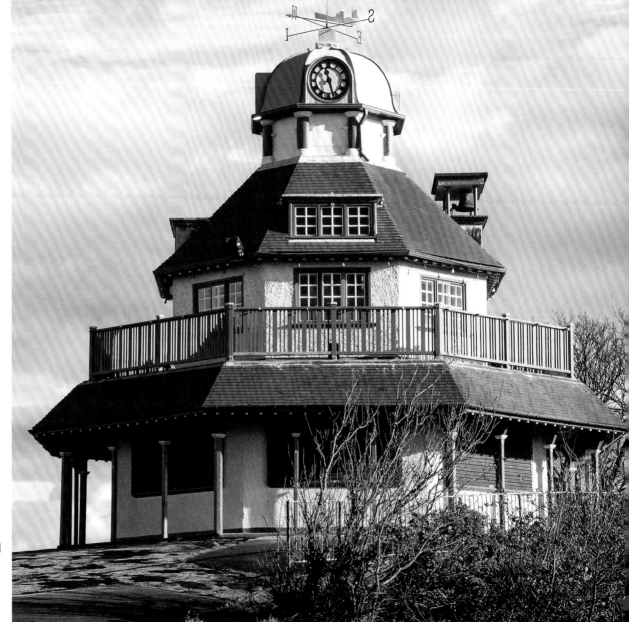

The Mount, Fleetwood

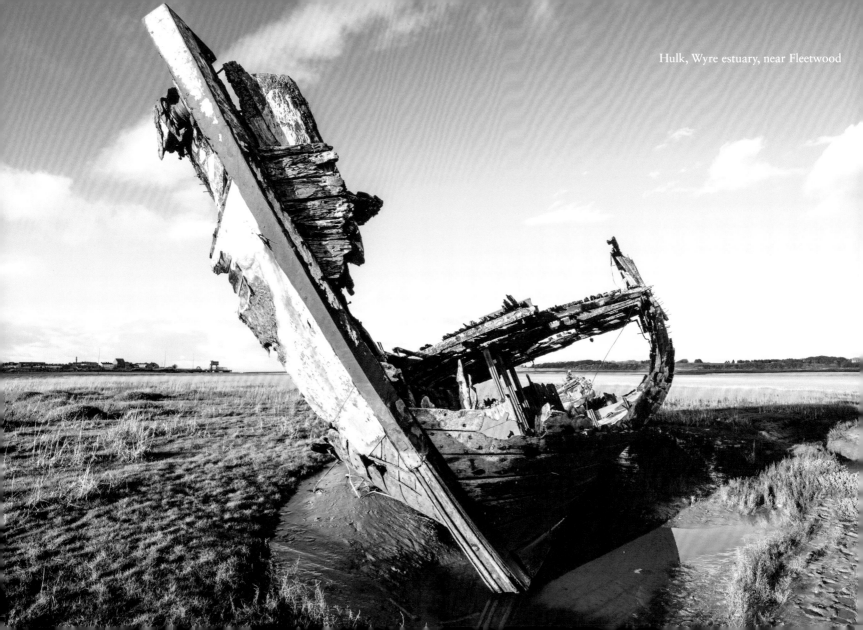

Hulk, Wyre estuary, near Fleetwood

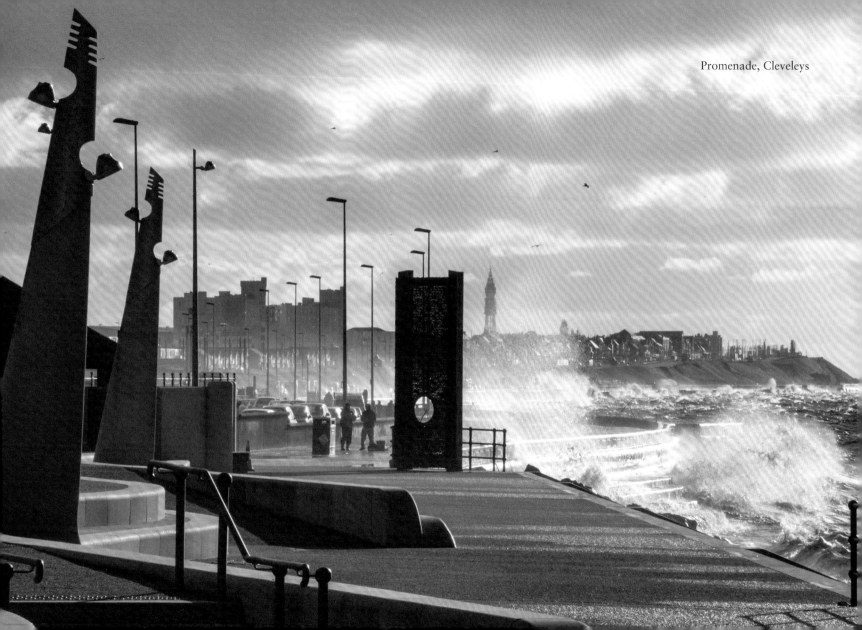

Promenade, Cleveleys

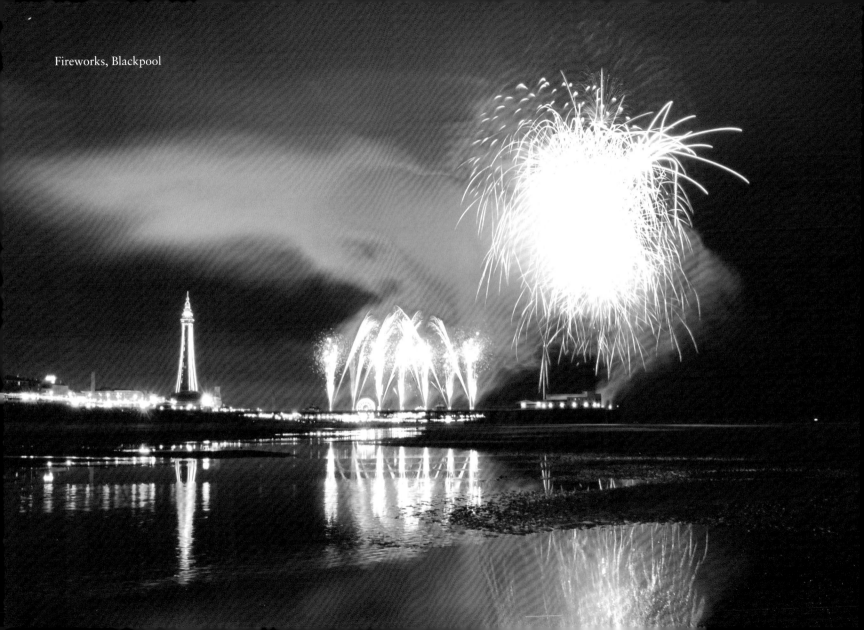

Fireworks, Blackpool

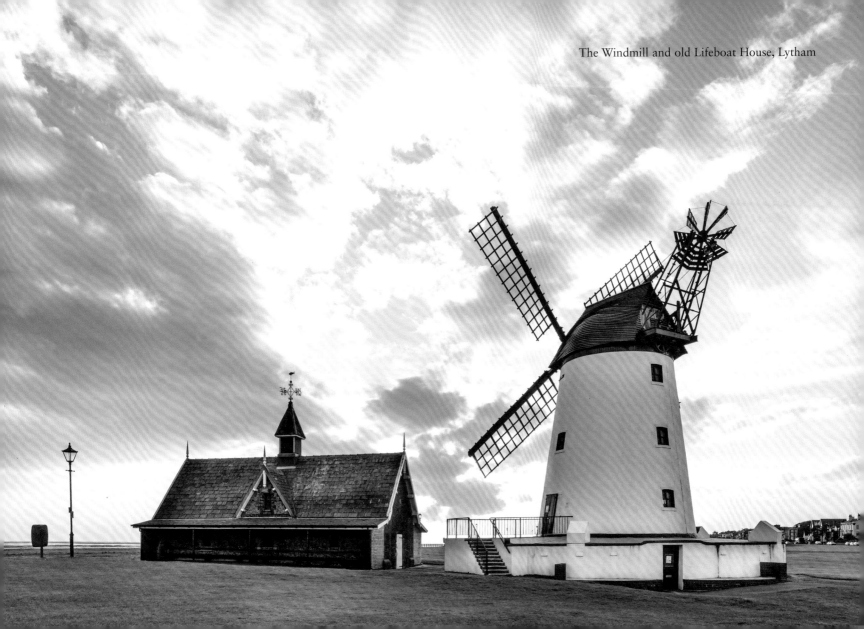

The Windmill and old Lifeboat House, Lytham

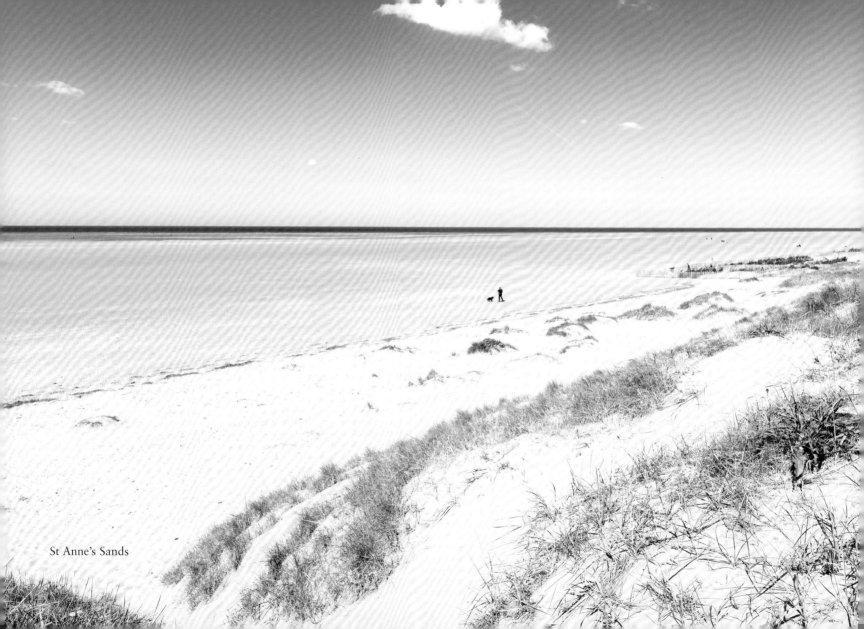

St Anne's Sands

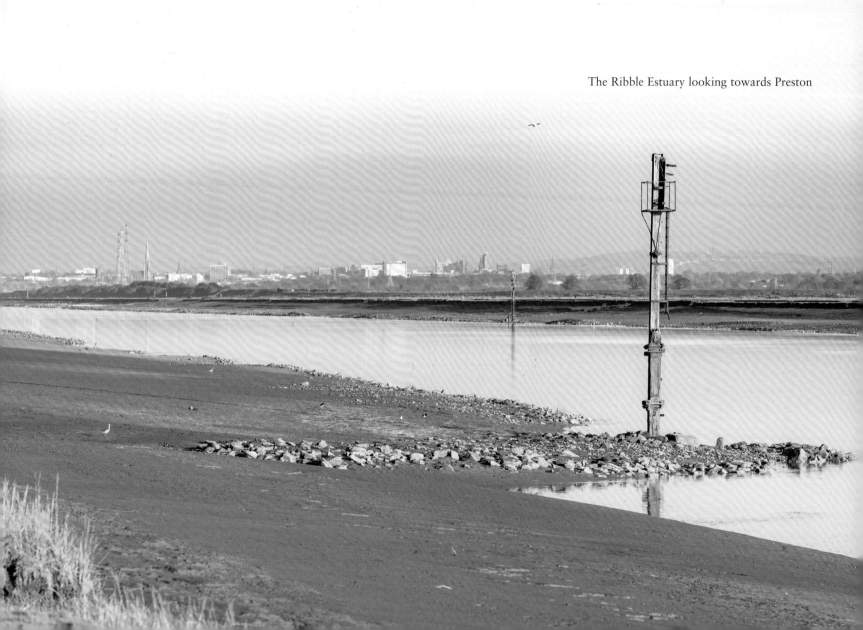

The Ribble Estuary looking towards Preston

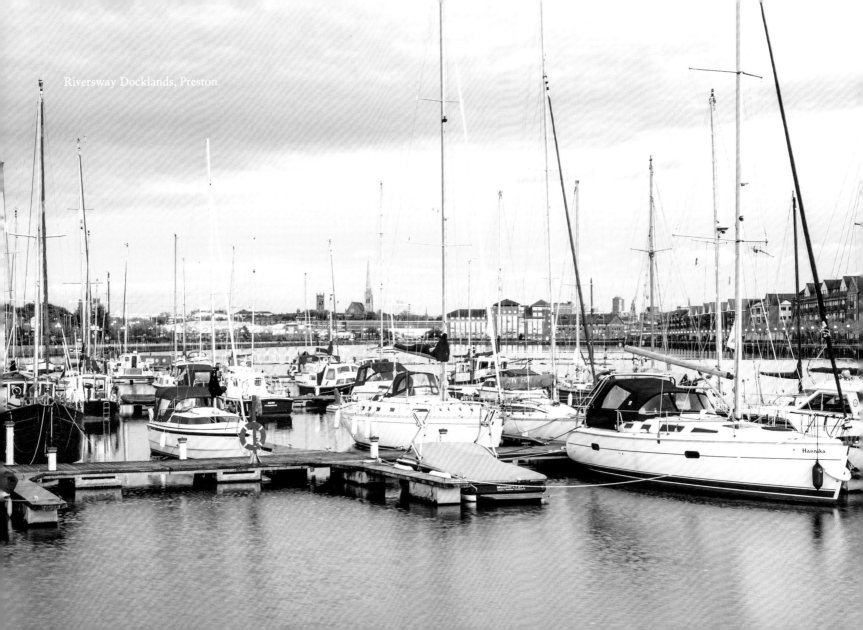

Riversway Docklands, Preston

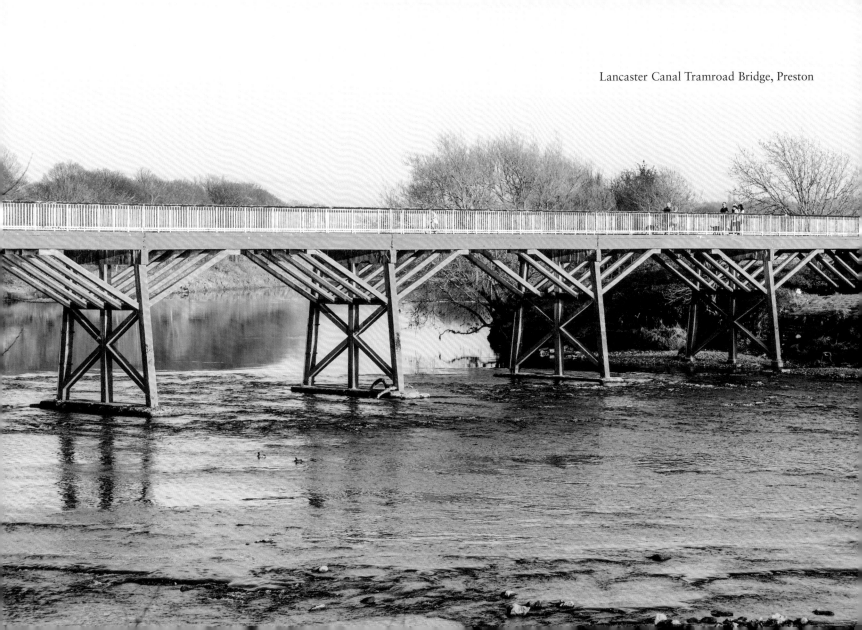

Lancaster Canal Tramroad Bridge, Preston

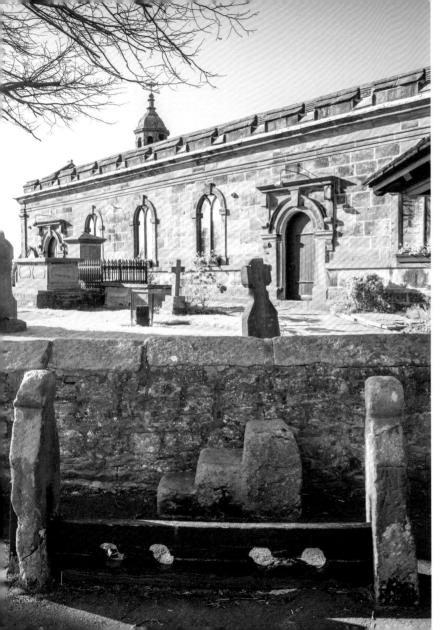

Stocks and St Anne's Church, Woodplumpton

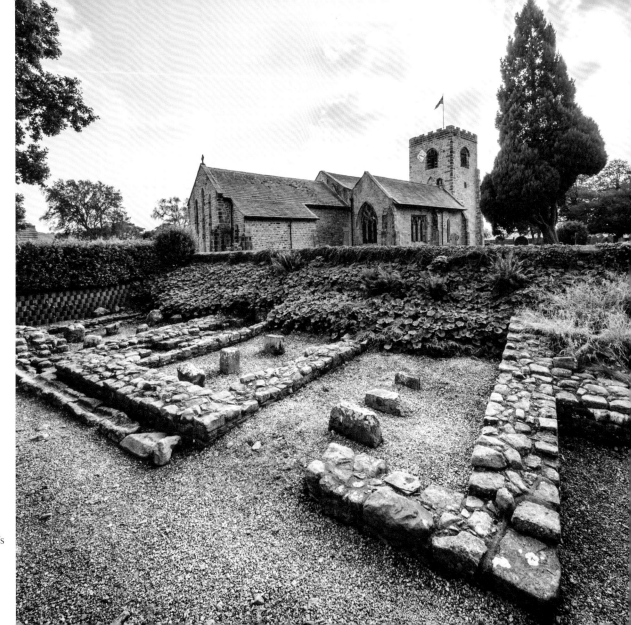

Roman granaries and St Wilfrid's
Church, Ribchester

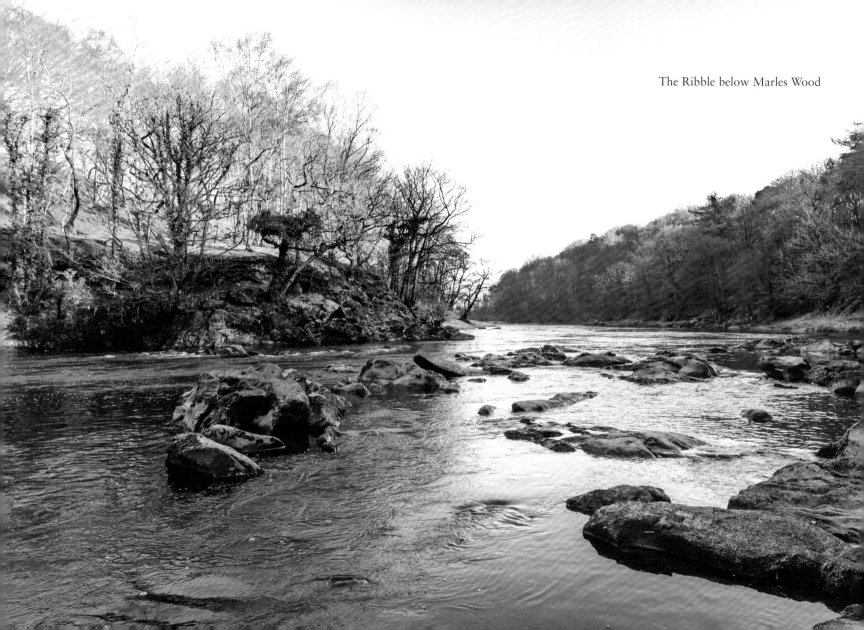

The Ribble below Marles Wood

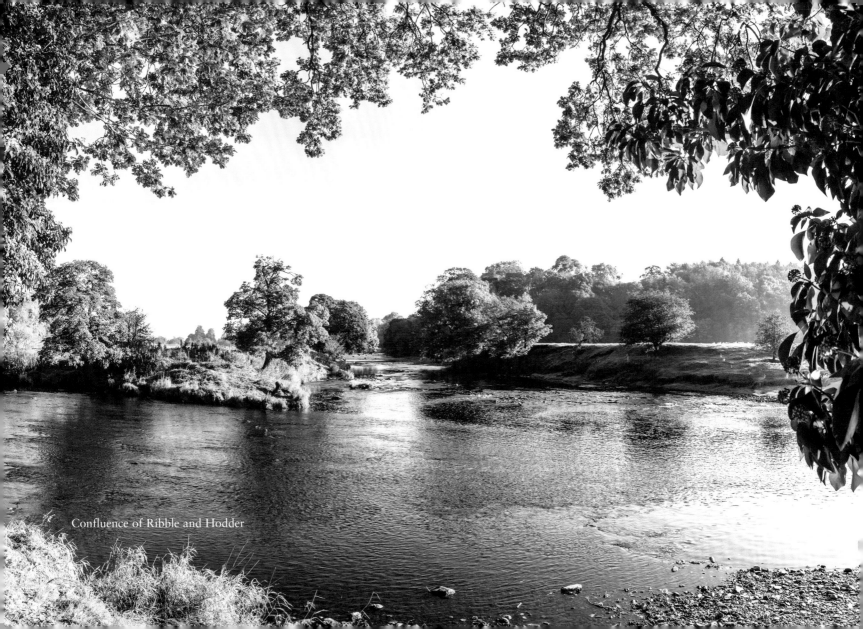

Confluence of Ribble and Hodder

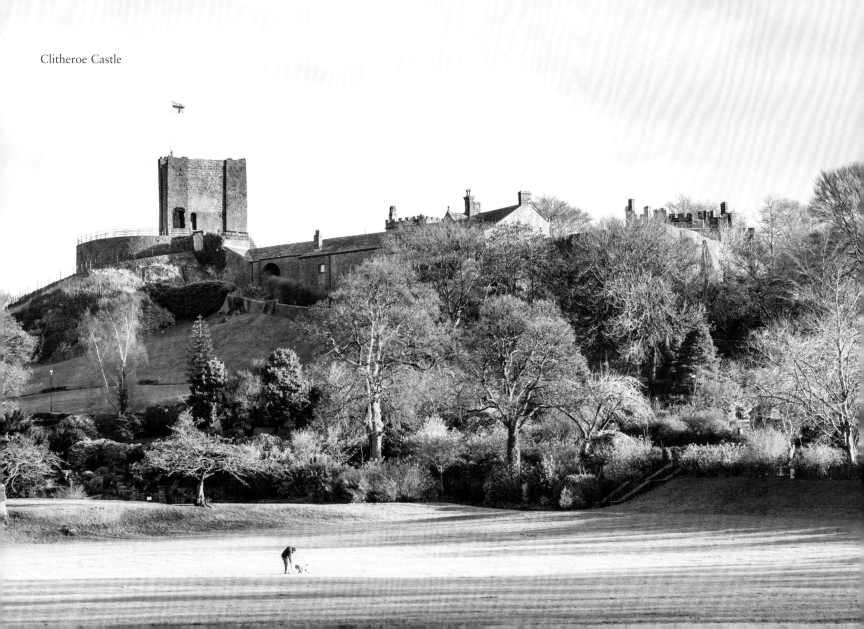

Clitheroe Castle

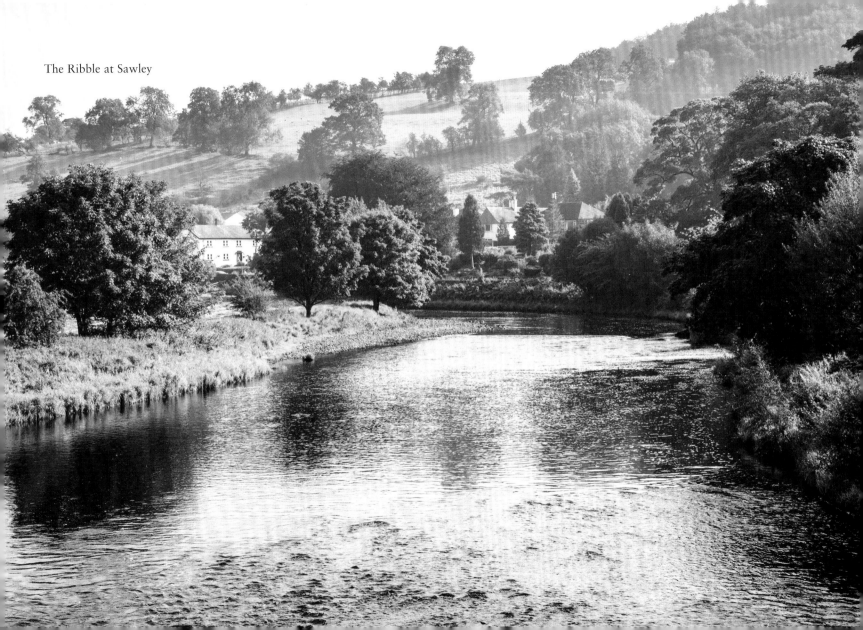

The Ribble at Sawley

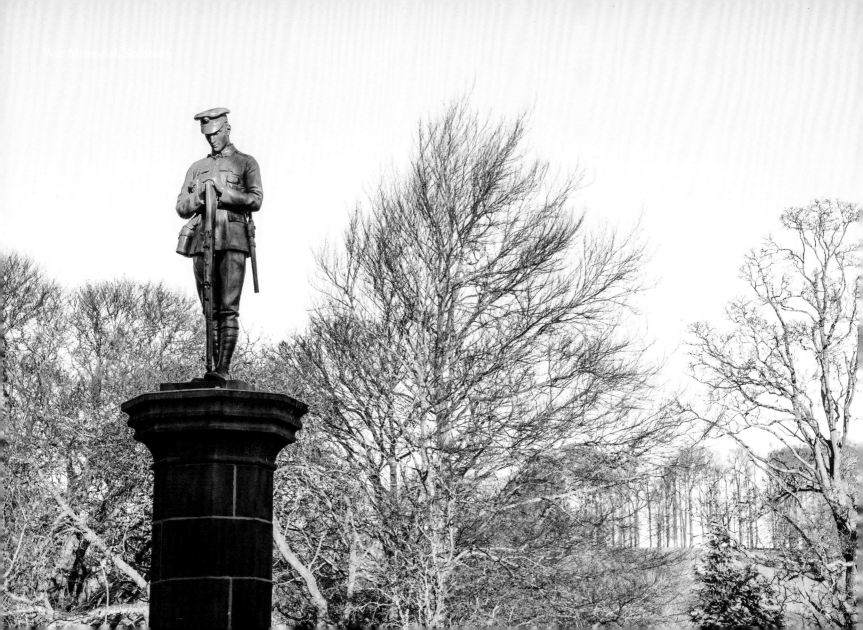

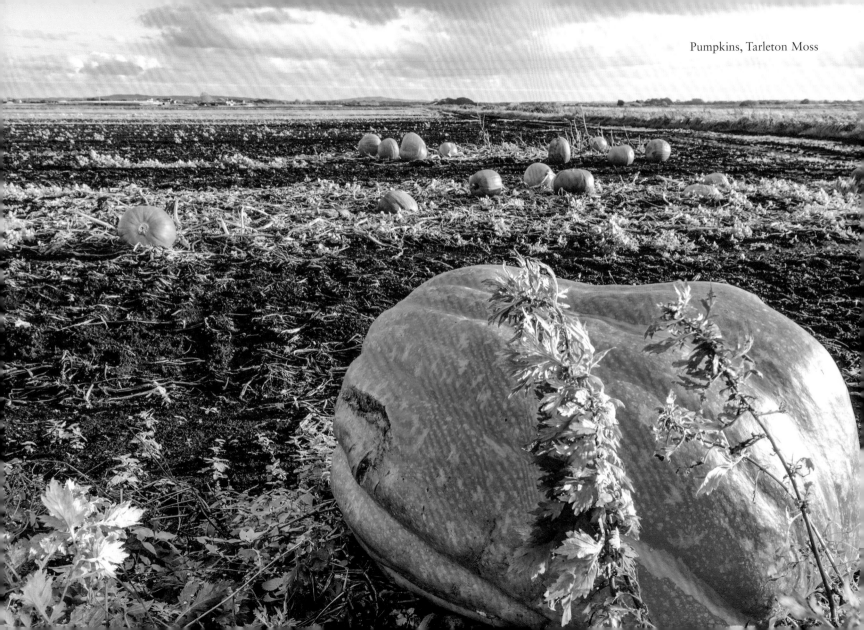

Pumpkins, Tarleton Moss

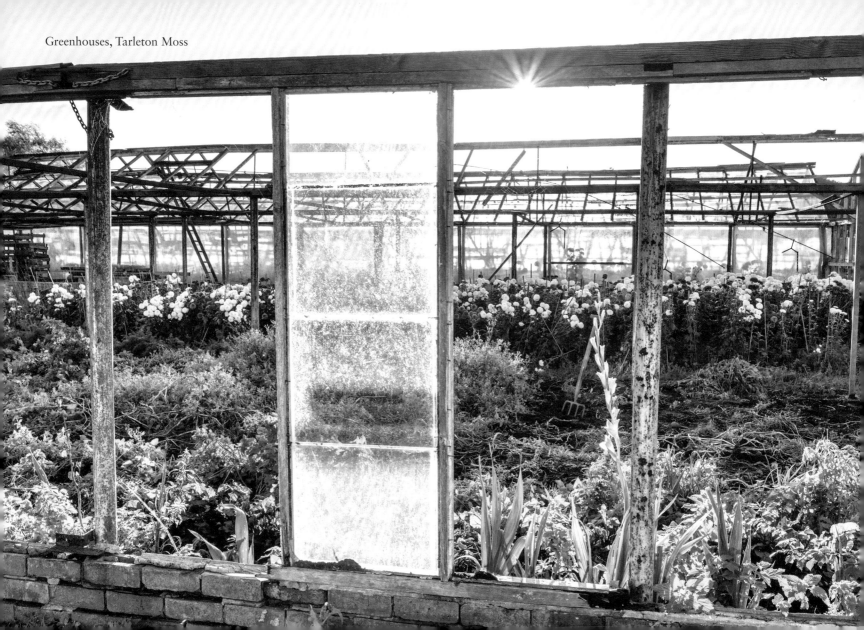

Greenhouses, Tarleton Moss

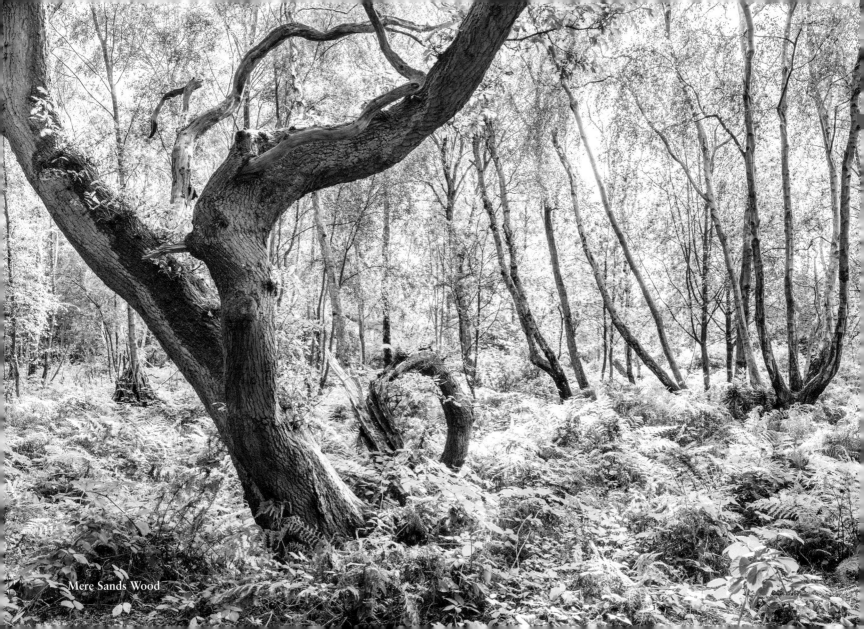

Mere Sands Wood

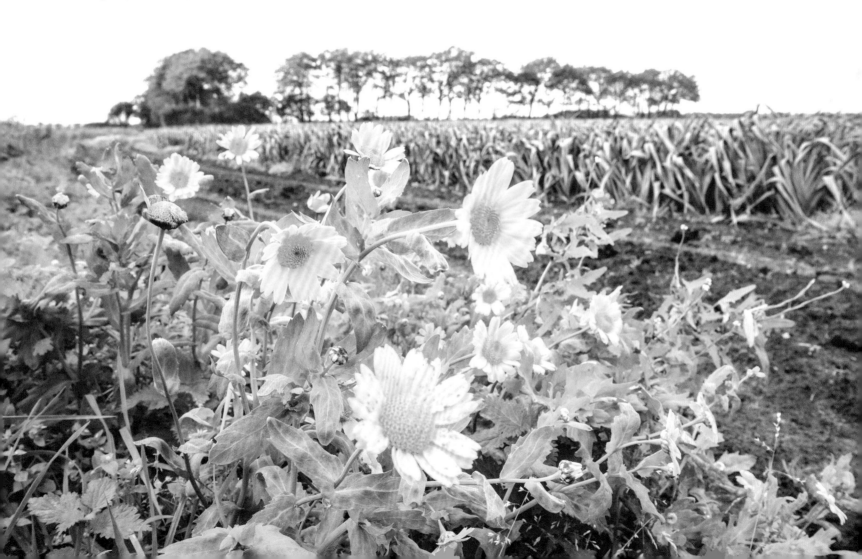

Corn Marigolds, Mere Lane, Rufford

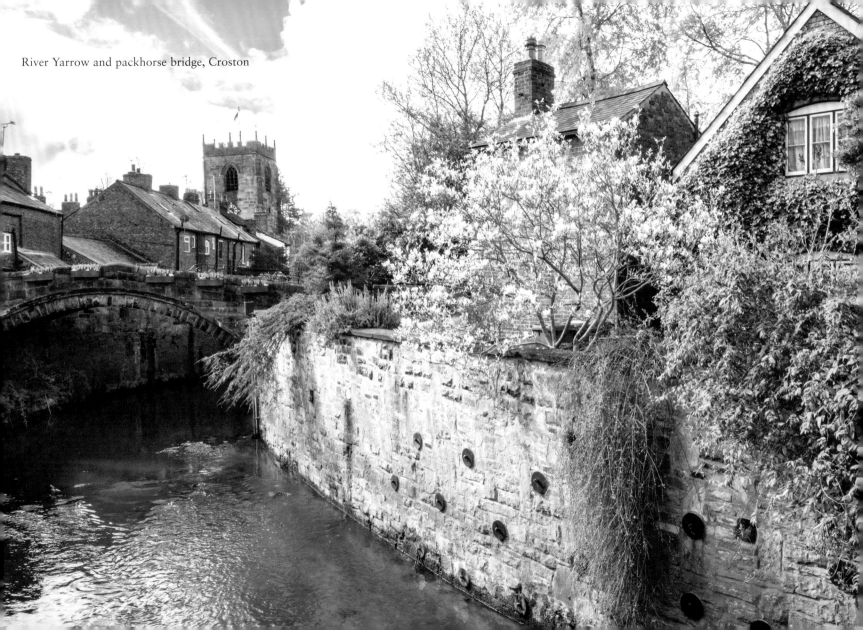

River Yarrow and packhorse bridge, Croston

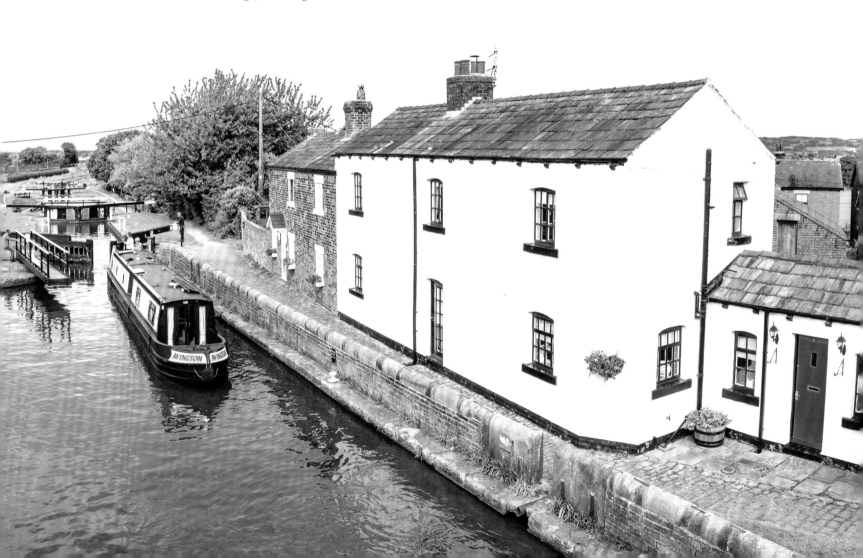

Rufford branch canal at Glover's Bridge, Burscough

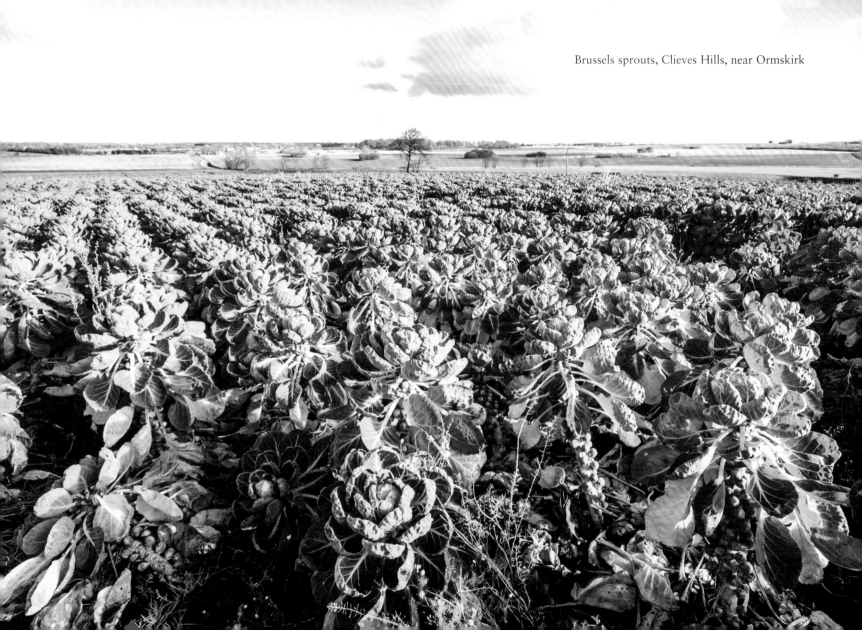

Brussels sprouts, Clieves Hills, near Ormskirk

The Pennines from Clieves Hills

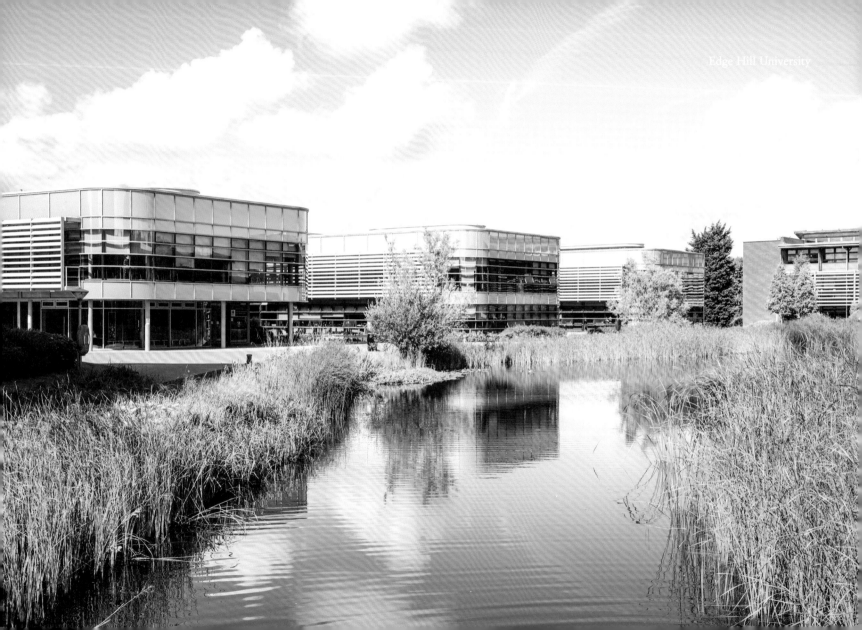

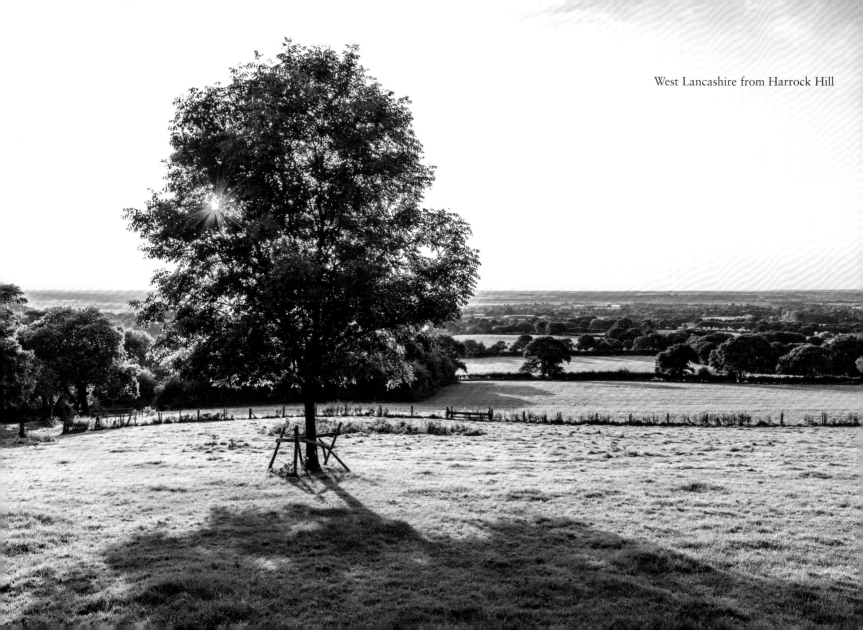

West Lancashire from Harrock Hill

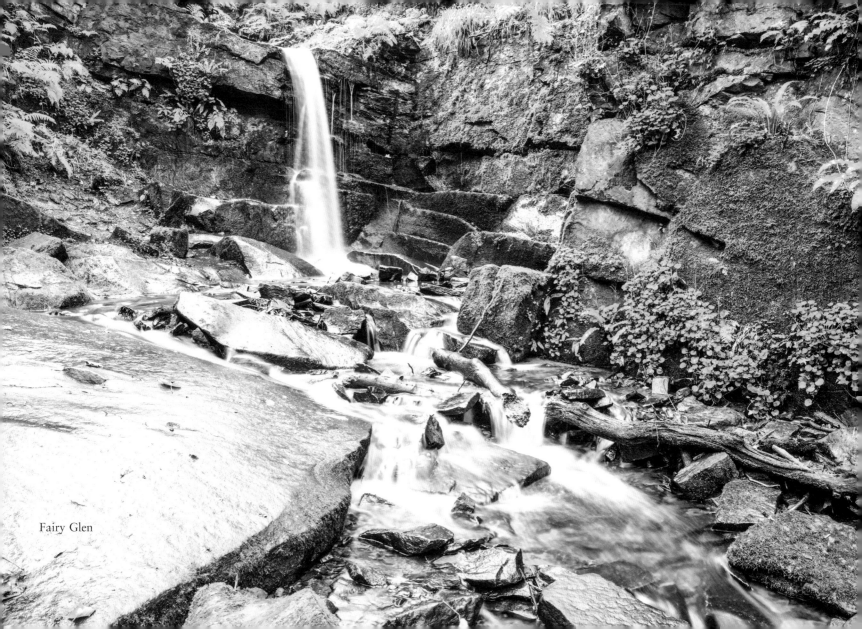
Fairy Glen

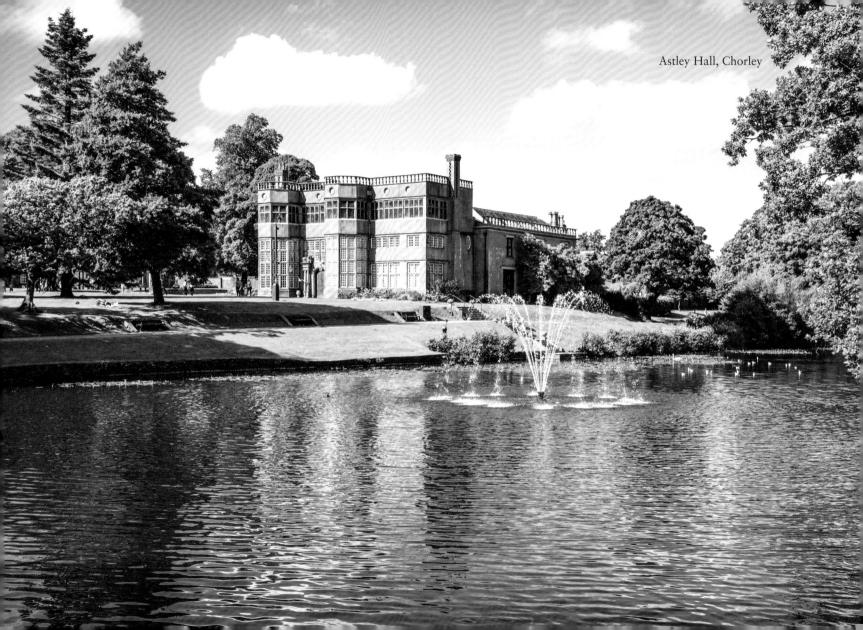

Astley Hall, Chorley

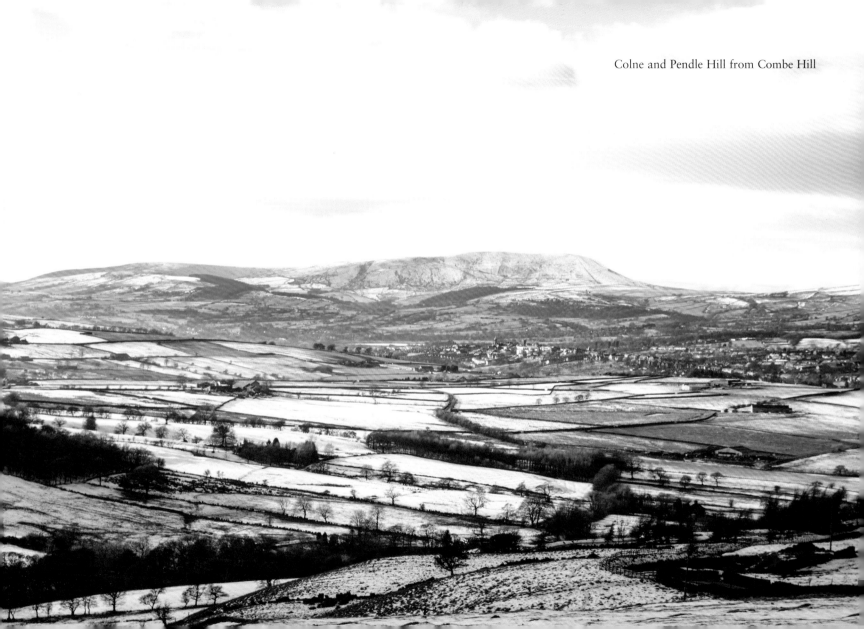

Colne and Pendle Hill from Combe Hill

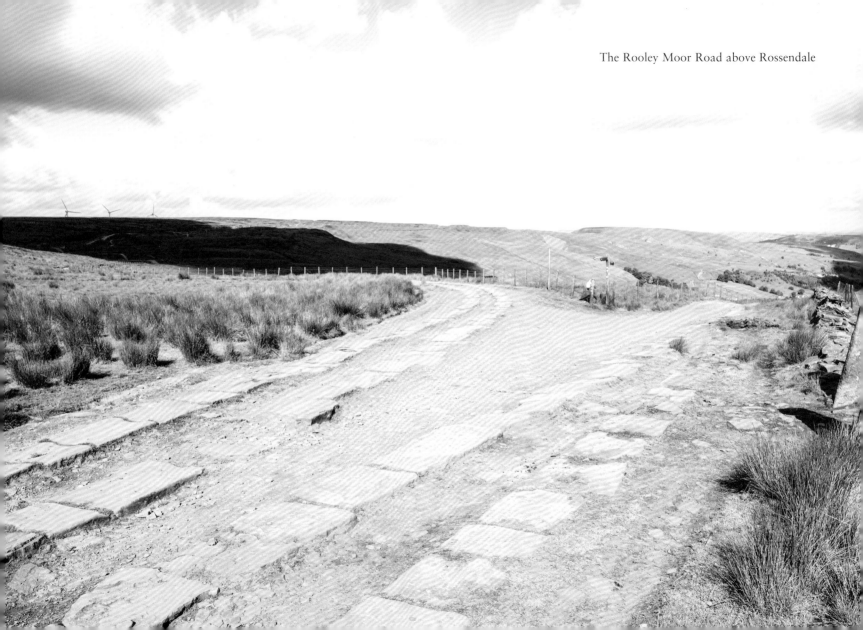

The Rooley Moor Road above Rossendale

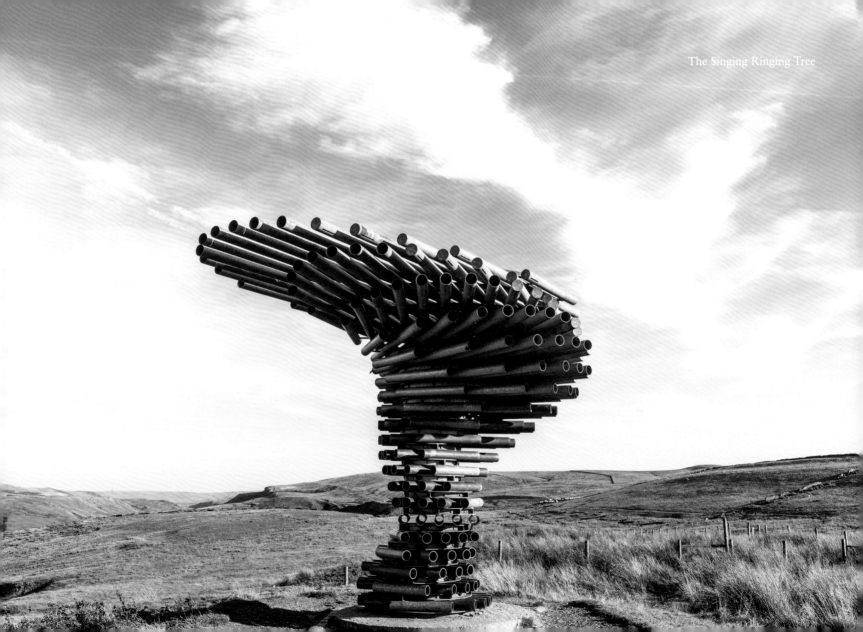

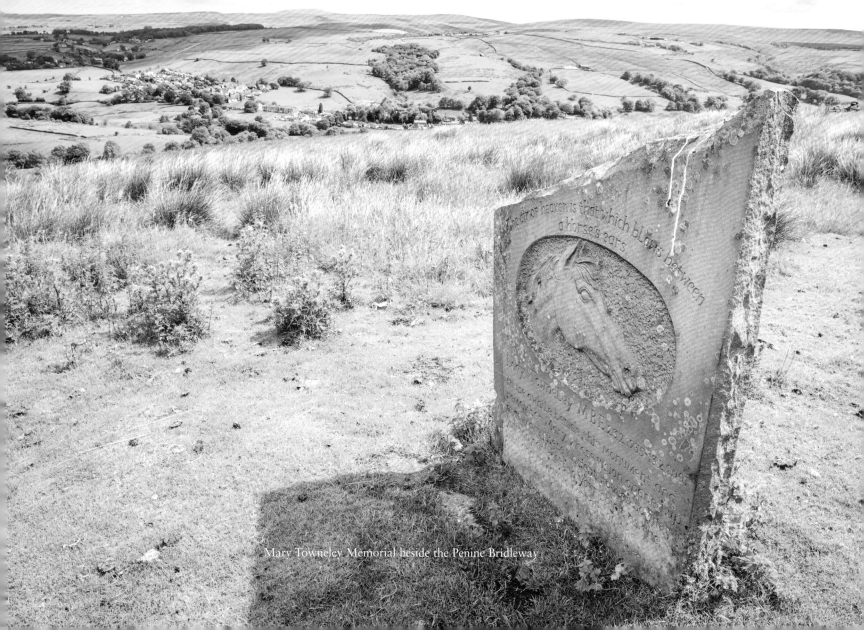

The air of heaven is that which blows between a horse's ears

Mary Towneley MBE 1332 1935–2001 who conceived this monument and whose vision opened up this bridleway...

Mary Towneley Memorial beside the Penine Bridleway

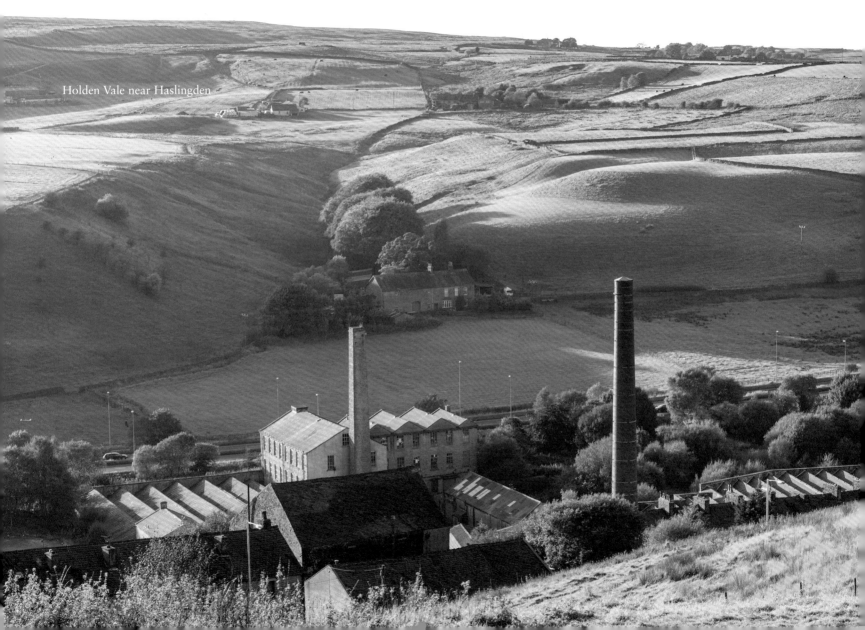

Holden Vale near Haslingden

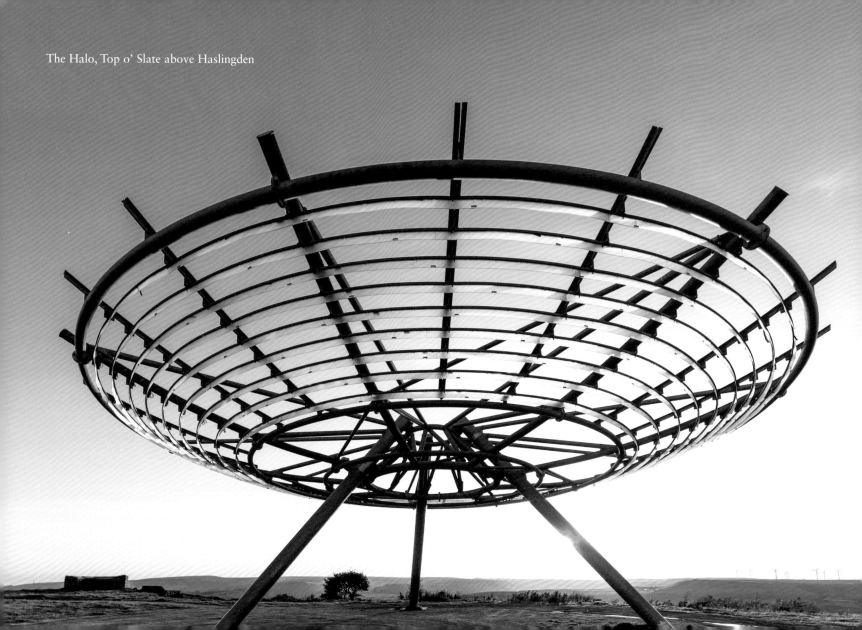

The Halo, Top o' Slate above Haslingden

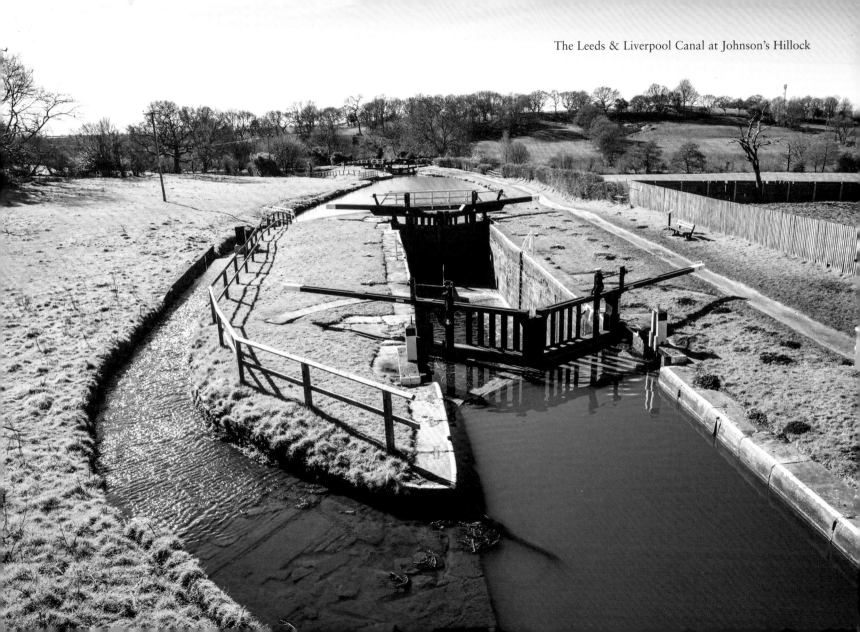

Rivington Terraced Gardens

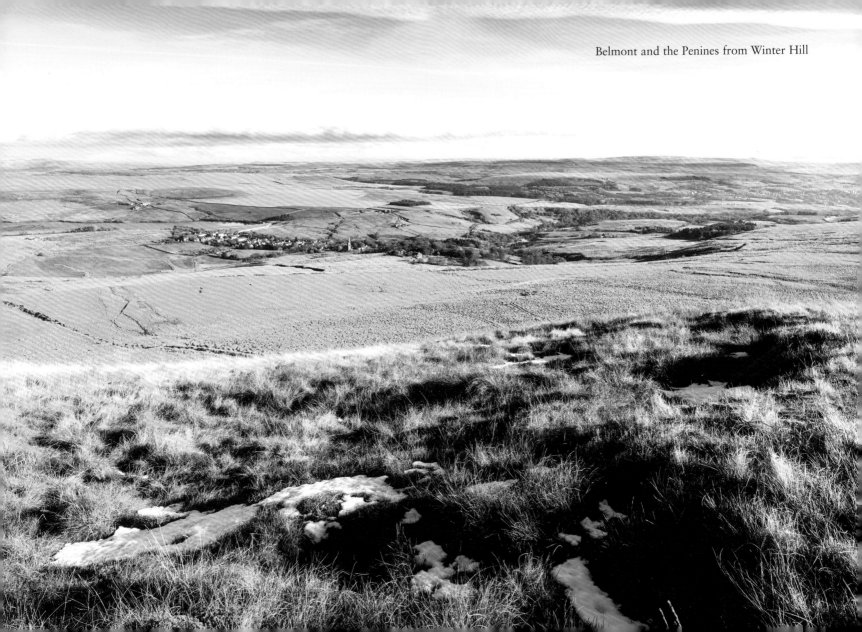

Belmont and the Penines from Winter Hill

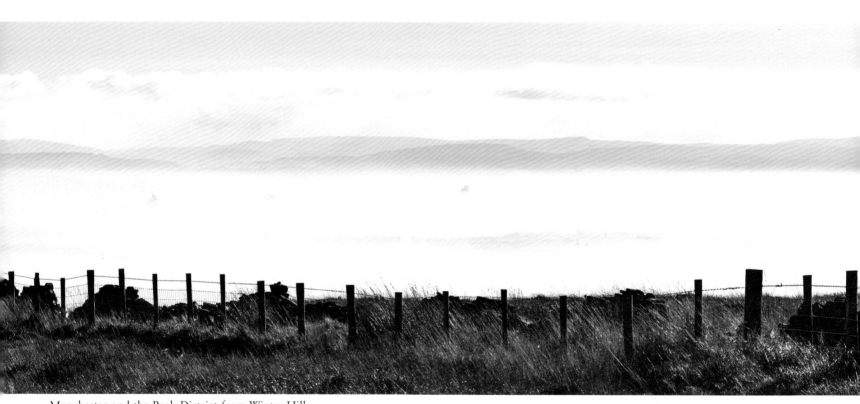

Manchester and the Peak District from Winter Hill

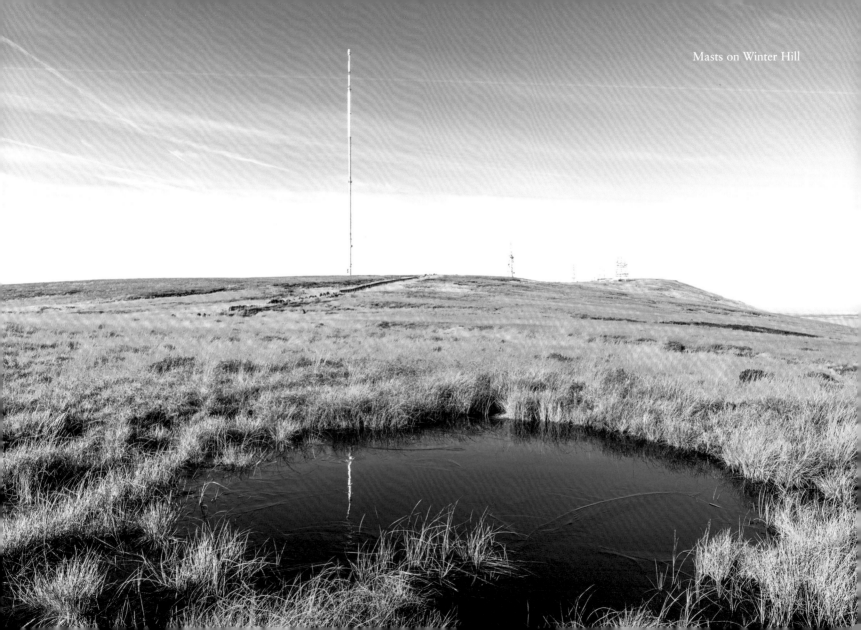

Masts on Winter Hill

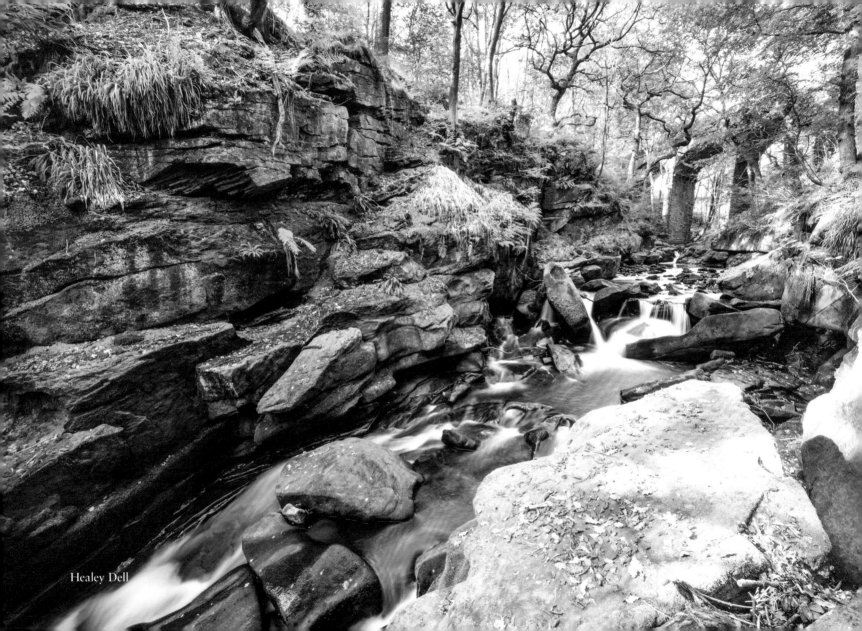

Healey Dell